LOST BARNSLEY

KEIRON DUNN

AMBERLEY

First published 2024

Amberley Publishing
The Hill, Stroud
Gloucestershire, GL5 4EP

www.amberley-books.com

British Library Cataloguing in Publication Data.

A catalogue record for this book is available from the British Library.

ISBN 978 1 3981 1507 1 (print)
ISBN 978 1 3981 1508 8 (ebook)

Origination by Amberley Publishing.
Printed in the UK.

Contents

Introduction

Roy Sabine was a freelance photographer and contributor to the *Barnsley Chronicle*. A selection of his photographs along with contemporaneous articles chronicle the cultural schism of the sixties and early seventies and form the basis of this book. The term 'Lost Barnsley' is in this case the passing of a seminal era.

The Second World War was recent history and in 1962 wartime cooperation was evoked for National Productivity Year. In the same year an urgent appeal was issued for youths to get a polio vaccine following an outbreak in Bentley near Doncaster. A new vaccine taken on a lump of sugar was made available as Enoch Powell, the Minister of Health, warned only 68 per cent of Barnsley's under nineteens were vaccinated.

The Strafford Oak at Tankersley made way for the M1. Centuries earlier the Earl of Strafford was arrested under the tree at Tankersley Old Hall and executed in the Tower of London in 1641. Darton Hall, a Tudor mansion built around 1568, was sacrificed to build a housing estate and subsidence was to blame when Worsborough ancient monuments Queen Anne's Lodge and Queen Anne's Obelisk were damaged.

When industrial housing called the 'Barebones' was cleared and the population moved to outer areas, one of the town's oldest churches, St John's on Duke Street, containing a 1921 oak memorial panel dedicated to 140 men from the parish lost in the First World War, was demolished.

In 1970 the *Barnsley Chronicle* introduced a Women's Page and printed Barnsley's Top 20 published by Neal Music in the Arcade. The strip cartoon 'Barnsley as It Never Was' replaced the lugubrious Owd Sam who would say 'Tha lewks a bit sluffened t' neet'.

The growing generational divide brought challenges. Barnsley Town Council wanted to ban art students from the Civic Hall because of outrageous and utterly disgraceful behaviour in the Centenary Rooms. At Barnsley Magistrates Court a youth admitted cultivating twelve cannabis plants in his greenhouse from budgie seed!

BBC2 and Colour TV arrived but in 1966 Barnsley Telephone Service said many townsfolk were still waiting for a home phone. At the same time vandals were putting vital public call boxes out of action which, according to the fire brigade, caused a delayed response as a fire in Midwood Sports was left to burn it to the ground.

Grand proscenium arch theatres the Globe and the Royal were now bingo halls. Max Wall presented a £700 cheque to Joyce Goodier at Top Rank Bingo, and Showboat, a seaside-style amusement arcade, was opened by *Coronation Street*'s Pat Phoenix.

In 1970 Harry Worth made a sentimental journey to his boyhood home on Stone Row, Tankersley, just before it was razed to the ground. Me old flower Charlie Williams and Royston comedian Al Showman both starred in *The Comedians* and *The Wheeltappers and Shunters Social Club. Kes* was the big break for stars of the future. Lynne Perrie and her brother Duggie Brown were regulars of the local club circuit. Lynne, a singer, would move into *Coronation Street* as Ivy Tilsley.

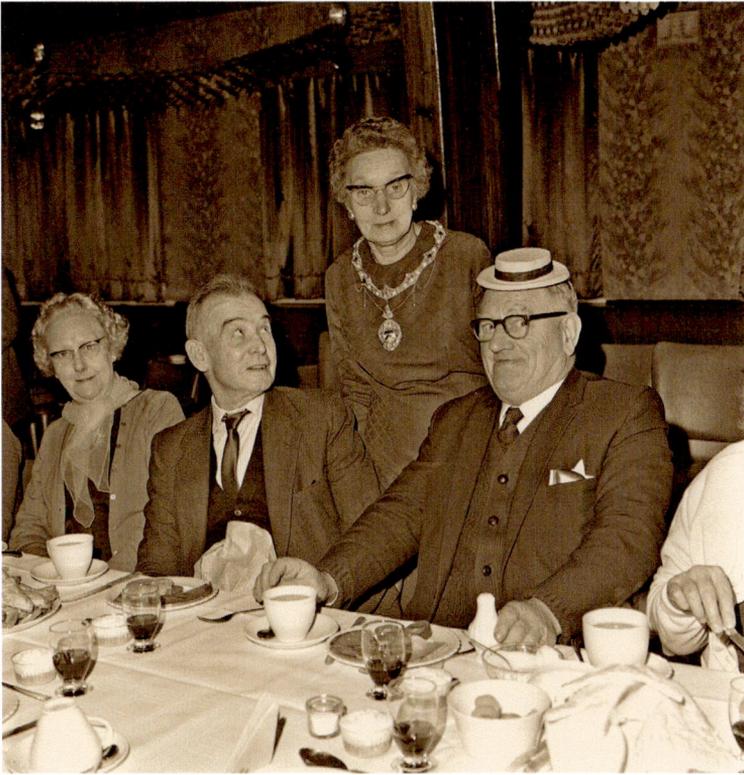

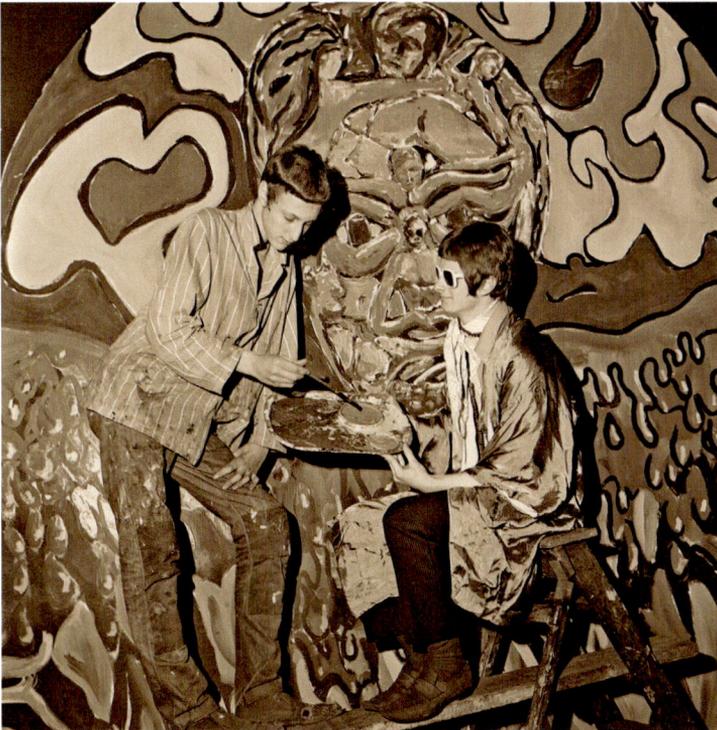

In 1968 councillors swayed by rumours that fluoridation would 'make the water taste funny' ignored the clear benefits and instead called for a referendum on 'mass medication'. One councillor said it was not about health but democracy and claimed those who wanted fluoride in their water should get tablets.

Local boroughs were often at loggerheads in a Local Government structure established in 1835. In 1970 Hoyland Nether Urban Council was offering a 9 per cent return for investment in the Council, bettering Barnsley Bonds 8.75 per cent. One suggestion was to replace local Boroughs with one mega Council run from Sheffield.

In October 1969 the *Chronicle* said British people didn't like change – in both meanings of the word – claiming the new 50p coin simply didn't feel like it was worth as much as the old ten bob note.

In 1969 Barnsley MP Roy Mason hosted Neil Armstrong, Buzz Aldrin and Michael Collins at 10 Downing Street. In 1970 'Nairn's Europe' launched a feud with the BBC when it compared Barnsley to a town in Belgium and implied the town was a dump. Mayor Frank Crow invited the BBC Director General and Nairn back to Barnsley so he could show them the town's other side.

Crow's proposal to 'frank' all letters with a slogan 'you can't cap modern Barnsley' was put on hold and Sydex 70, a 'Sell Barnsley' exhibition, was cancelled due to lack of support. Undeterred market trader Wynne Rolinks was on a personal mission to counteract the BBC's negative portrayal, putting an advert in the *Times* for her antique business in the market to show southerners that Barnsley was not just dirt and untidiness. She proclaimed if the market was in London, they would go mad with all the bargains they could get.

Besides the famed market, the white heat of technology was radiant at the Slazenger factory on Doncaster Road, Kendray, which had been making tennis balls for Wimbledon since 1902. In 1970 the company made a breakthrough in golf club design with max power clubs used by British Open champions Tony Jacklyn, Roberto de Vicenzo and Peter Thompson in this and the other majors.

Sign of the Times

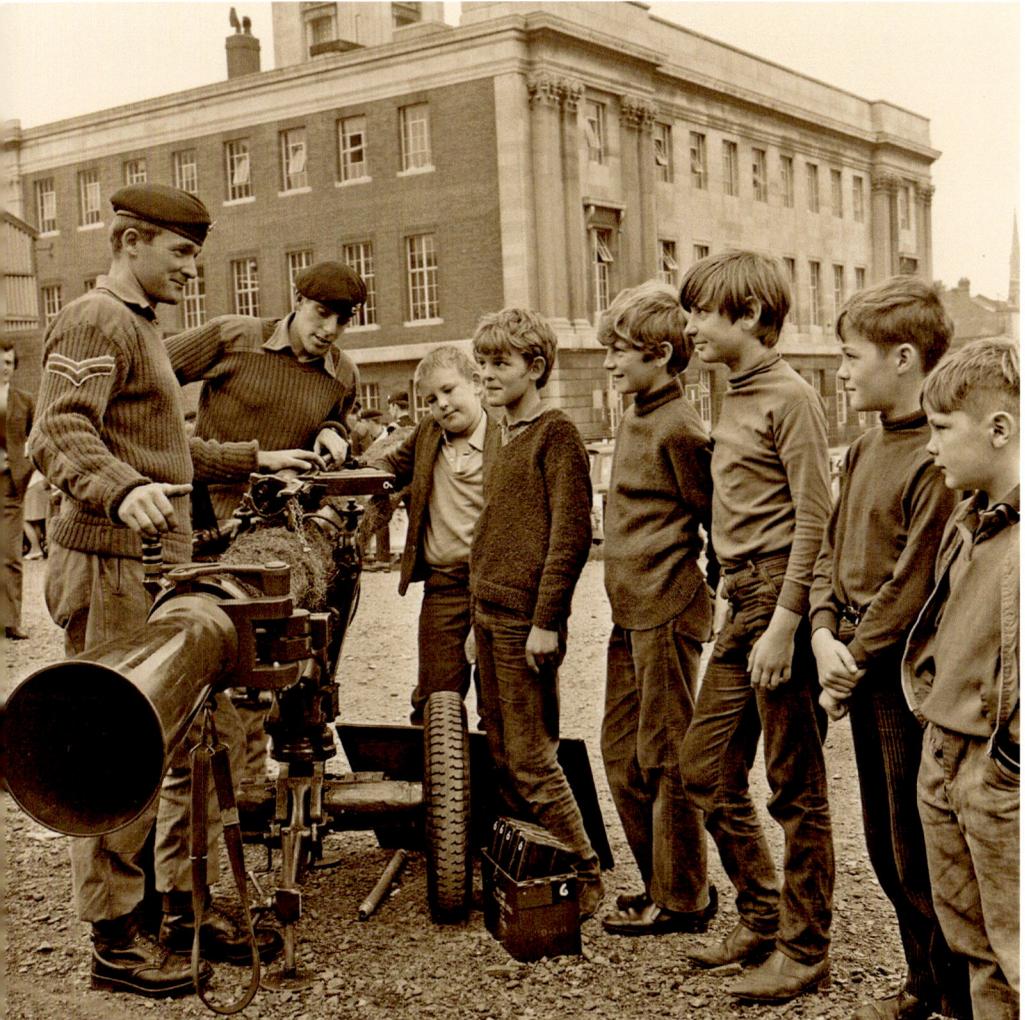

In August 1970 the Light Infantry were recruiting, whilst an article on the regiment needed special permission from the War Office. This was early on in the Troubles and it was reported that our lads were keeping the peace in strife-torn Belfast. One soldier said he was manning road blocks whilst being nice to locals. Another was on rooftops looking out for any move that could threaten the peace. One recruit had met his fiancée in Belfast and another said the job was tougher than mining.

The Barebones were being cleared and the residents were moved into sometimes poorly constructed new housing in outlying areas. Cllr Gordon Jepson complained about perfectly good streets being demolished, whilst uninhabitable houses remained occupied. He said the worst street in Barnsley was Shepherd Street where conditions were deplorable and residents would happily move into houses earmarked for demolition. One resident said rats ran down the street like dogs.

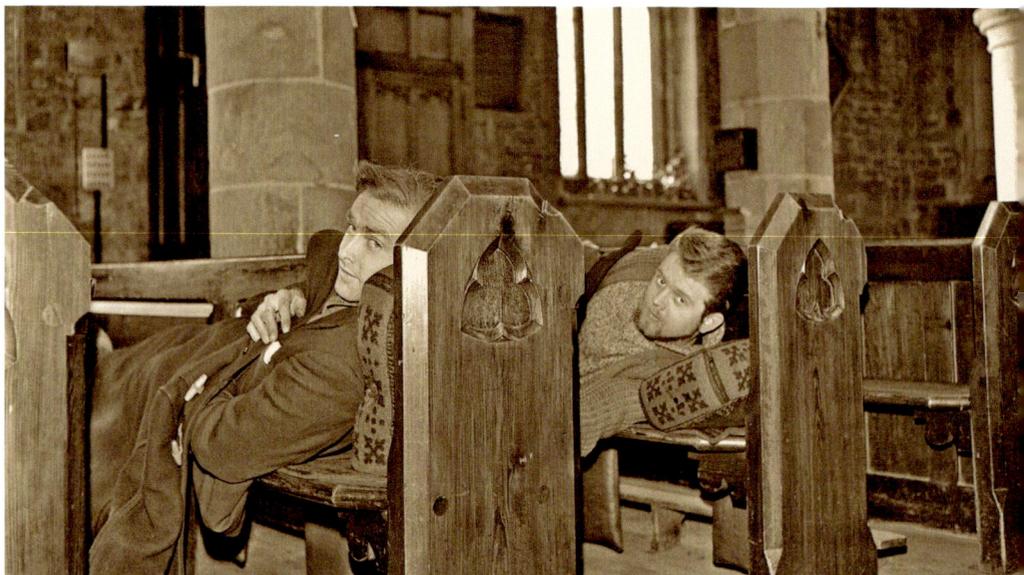

Sleeping on a pew in St Mary's echoed a special feature on the remaining lodging house in Barnsley. The Model Lodging House on Doncaster Road was registered by Barnsley Corporation to house seventy-four men and ten women in a separate wing. It was the cheapest lodging house in England. It was once put in quarantine following a smallpox outbreak. One man, handicapped due to an explosion in which five others died, travelled the country before moving to the lodging house. He made and played mouth organs.

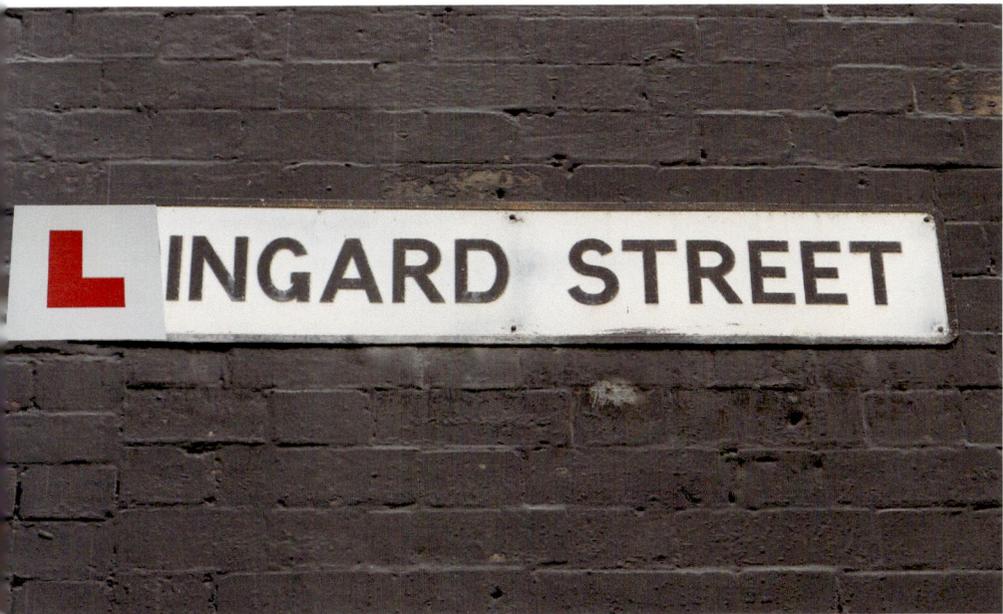

In 1968 future mayor Frank Crow said the concentration of learner drivers around the Huddersfield Road area and in particular on Lingard Street was putting the safety of children and old people at risk. To address the problem an alternative place for learner drivers was suggested by Councillor Crow. This was a dirt track in Lundwood.

In August 1966 the Barnsley Youth Temperance Council (BYTC) had a hangover after their £3,000 minibus was stolen and found crashed in London. The minibus was travelling around the county with a temperance bar. The BYTC, one of the largest Youth Councils in the country, was granted sole 'drinks agency' for certain non-alcoholic drinks but had £200 worth of drinks stuck in a warehouse. The BYTC were left selling pens and pokers to raise funds and to make matters worse, membership was falling.

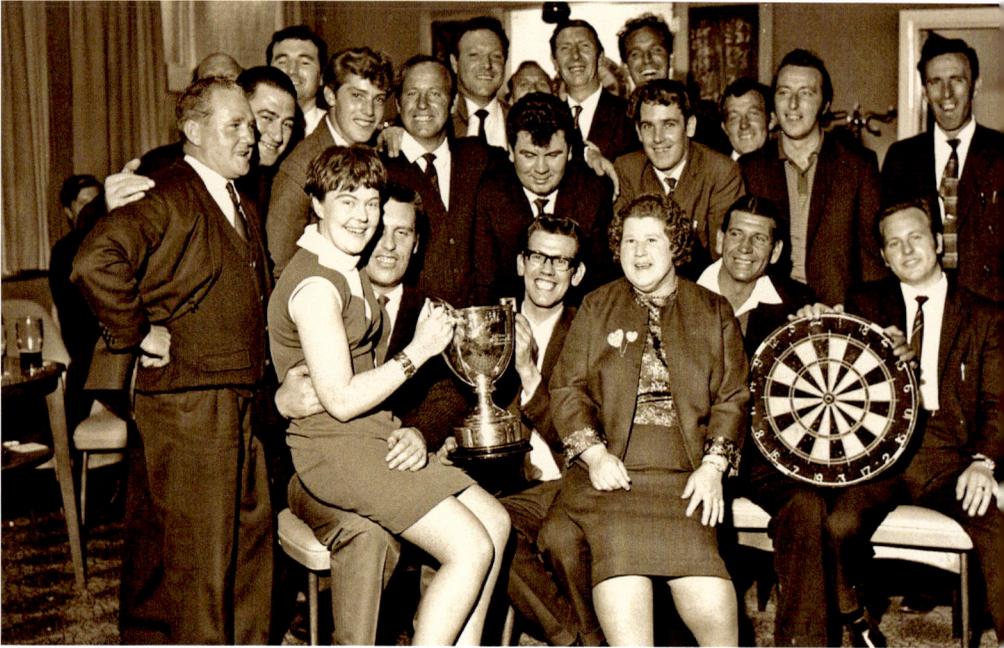

Celebrating winning the Darts League at the Springvale coincided with another memorable victory. Keith Jenkinson, the landlord of the Dalesman on Ardsley Road, Worsborough Dale, bought £20 worth of 1966 World Cup tickets including one for the final. Thinking he had lost them, he was distraught until he remembered that he had taken his suit to a tailor. They found his tickets in his pocket and returned them. A happy ending but the pub sadly was replaced with a housing estate.

Albert Hirst's Barnsley Chop is on menus around the world. At the Queens Hotel the Catenian Association dinner attendance sky rocketed when it became known that Barnsley Chops were on the menu. Tragically there were not enough, so half had to make do with a T-bone steak. In 1969 Albert's black puddings were awarded a gold medal at the Black Pudding Olympics. On hearing that Princess Anne thought they were something to hang in a living room, Albert sent Buckingham Palace some of his black puddings, which received royal approval. The letter hung in Albert's Queens Road premises.

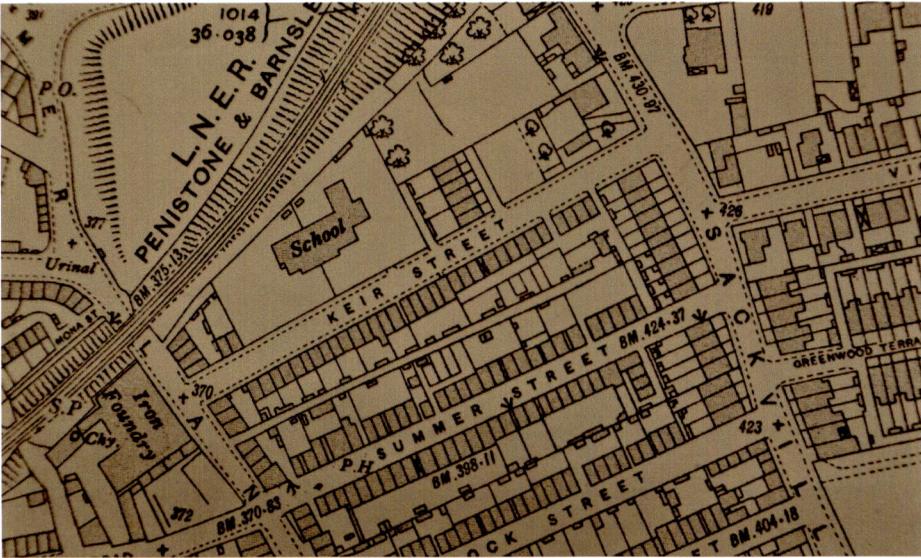

A chill came over Winifred and Kathleen Fenney's house on Summer Lane when ghost Albert Seaton made household items move. To scare him off they placed a Bible on a table but it turned over, a wardrobe was smashed and their mother's dog refused to go inside. Moving back to their mother's house on Keir Street, medium Edward Pike from the Barnsley Spiritualist Church made a tape recording of a séance. Albert said he was robbed of his rightful inheritance; he was not evil but wanted revenge. Mr Pike told Albert he was punishing the innocent. Albert promised 'I will not harm them'.

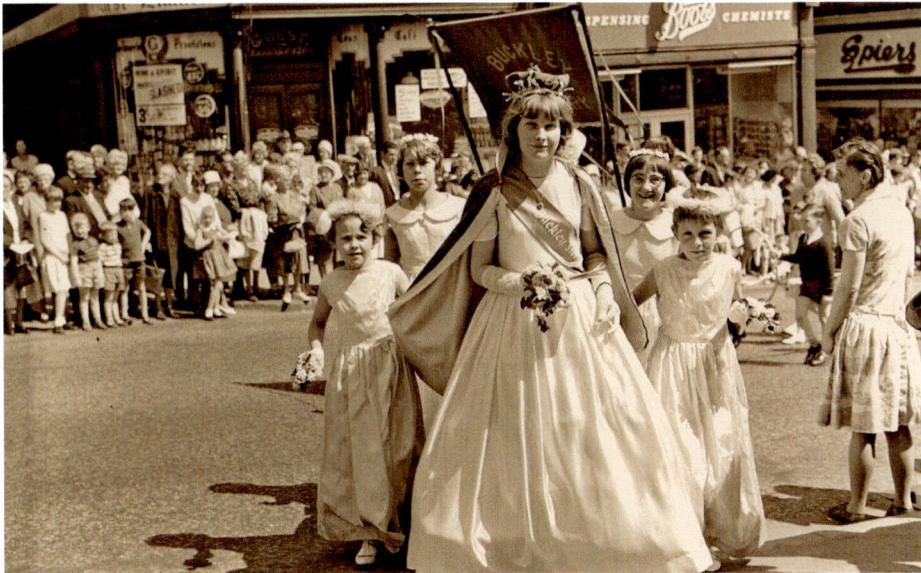

In 1968 the annual Whit Walk embraced Sunday schools from sixteen churches and was attended by thousands. The parade started at Pitt Street Methodist Church and went through the town before ending outside the Trafalgar Hotel. However, the 1967 walk was scuppered by the new Spring Bank Holiday. First, it was moved to avoid a clash, then rain washed it out. Announcing the new date in early June, the organiser, Mr W. Pierrepoint, blamed gradual changes in society.

Monsoon Monday in August 1968 did not deter people leaving Barnsley for Feast Week. Despite escalating car ownership British Rail put on extra trains. Through trains to Blackpool, Bridlington, Filey, Yarmouth and Cleethorpes started from Elsecar and Hoyland, calling at Wombwell and Barnsley. However, the Barnsley Chamber of Trade raised concerns about national multiples, ignoring local tradition and being open for business as usual. Local shops had traditionally closed on Monday and Tuesday of Feast week.

The new August Bank Holiday led to fears that the traditional Barnsley Feast week could be killed off with stores turning the local holiday into a normal shopping period. Colin Dransfield, the Cooperative's president, promised to follow tradition, saying staff don't want to be working when the rest of their family are on holiday. However, N. Corah (St Margaret) Ltd decided not to recognise the Barnsley feast in 1971. Instead, their employees would be told to take the last two weeks off in June.

At this time beauty contests were commonplace. Coal Queen 1970 Miss Sue Vallely picked up a new bicycle from Sam Bullough at the NUM offices. It was part of her prize for being chosen at the annual Mineworkers Gala in Pontefract. In March 1967 Miss Bathing Beauty was staged at the Civic Hall as part of the annual invasion by Scottish Busmen. Benns Furniture Store on Peel Street was opened by Miss United Kingdom Jennifer Lowe. Miss World 1964 Ann Sidney starred at the Civic in *Mother Goose*.

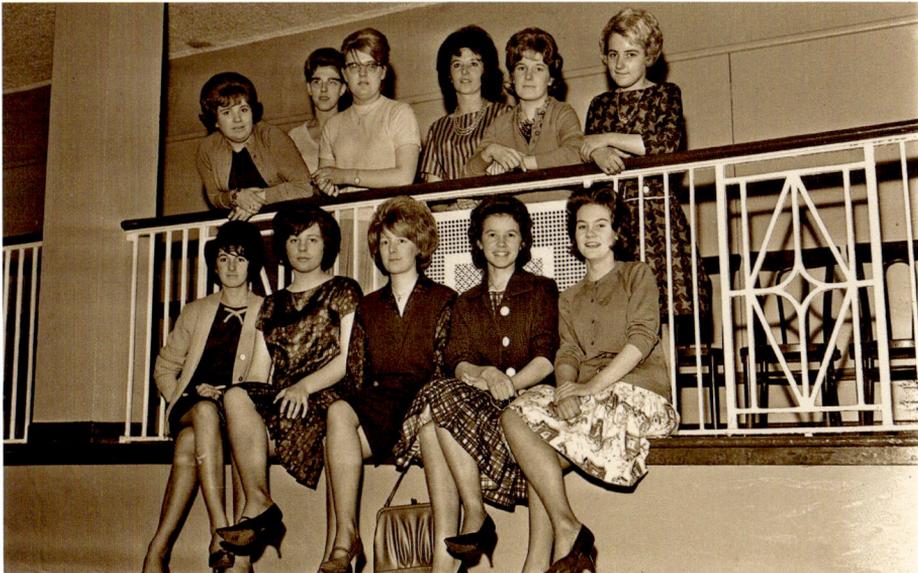

The Star Queen Competition took place in November 1962. Linda Batty was Miss Corah (Barnsley) 1966 and became National Miss Corah at the final held in Leicester. In October 1970 a heat of Miss Nightclub of Great Britain was held at the New Monk Bretton including a wig display by Coiffeur Des Dames. In July 1970 Janice Williams was one of the ten finalists in the nationwide Goal Girl 70 contest to find Britain's top female football fan at London's Waldorf Hotel. Janice was a West Ham fan!

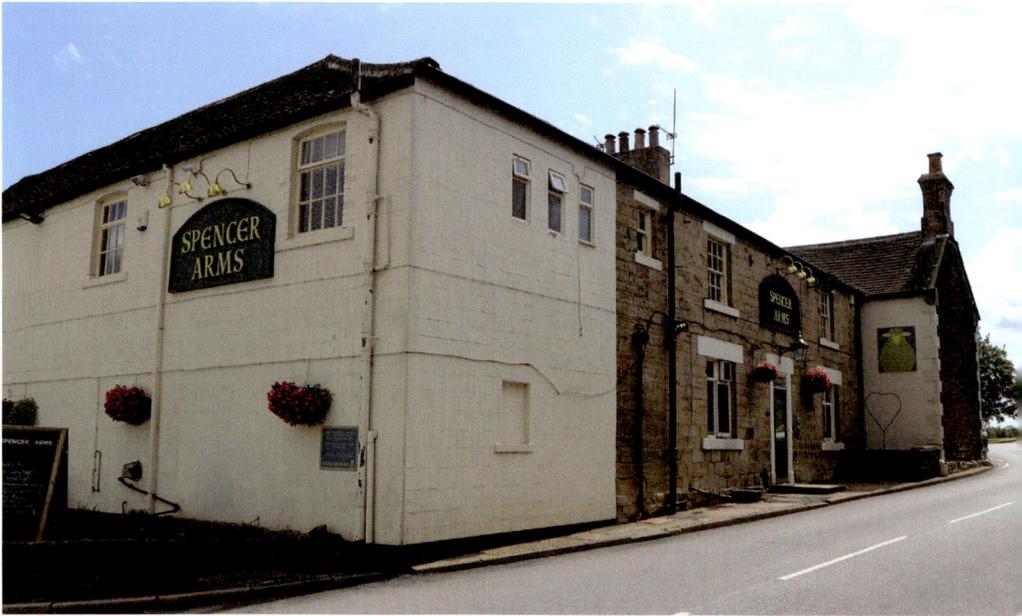

The *Chronicle* said the 1967 'breathalyser act' was the most hated legislation since the Corn Laws. They insisted the police should not be blamed for this most disagreeable law after villagers near Barnsley boycotted the local police ball in protest. Landlords of isolated country pubs were complaining; at the Spencer Arms in Cawthorne turnover was cut by half and the landlord threatened to pack it in! They were more sanguine at the Cherry Tree in High Hoyland, having sold more shandy.

Pubs, Clubs and Bands of the Time

Featuring Dave Dee, Dozy, Beaky, Mick and Tich, Chris Farlow and the Thunderbirds, The Bonzo Dog Doo-Dah Band and The Tiles Big Band, the 'All Day Rave' was on Easter Monday in 1967. The town has produced many notable musicians. In 1968 singer George Davies, aka Ulysses Smith, released his first single 'Jet Aeroplane' on RCA Victor. Dennis Lingard was the bandleader in the Ballroom scene from Richard Harris's breakthrough film *This Sporting Life* and had previously played clarinet and saxophone with the Ambassadors at Barnsley Baths.

Even with a Radio One Club roadshow hosted by DJ Dave Cash and an appearance by the Kinks, it was the Barnsley Folk Club which moved to the Centenary Rooms in October 1968 that would become the Civics' biggest attraction. Along with Tony Heald the celebrated folk artist Dave Burland of Worsborough Bridge founded the Folk Club in the early 1960s at the Alhambra. The club featured all the leading folk artists, including 'Fotheringhay' featuring Sandy Denny, which was described as the event of the year in 1970.

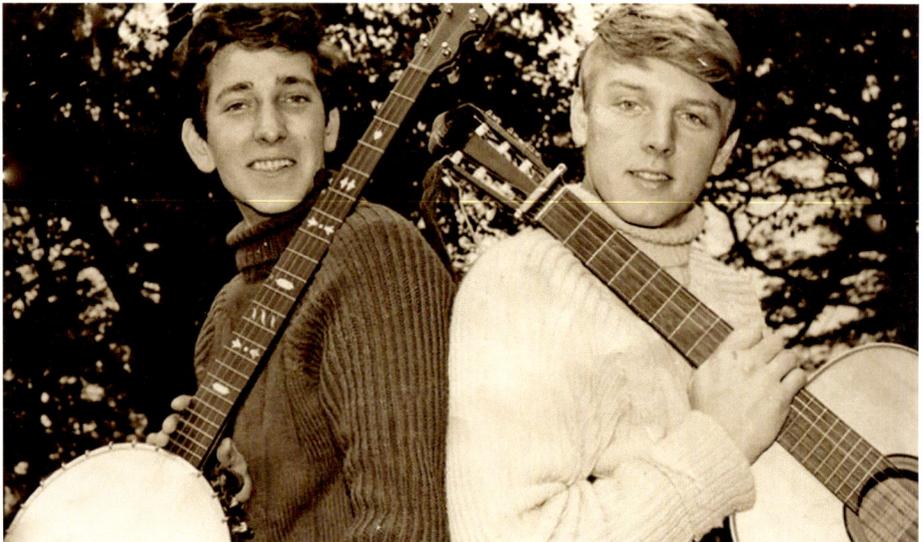

The first people from Barnsley to appear on TV and profile the area as contemporary folk singers were Danny Clarke and Lennie Wesley. They organised their own folk clubs in the Barnsley area at the White Hart, Ardsley WMC, Magnet bowling alley Lounge and Strafford Arms in Stainborough. They were discovered by Johnny Hamp at Granada TV (who discovered the Beatles) to appear on his *Firstimers* show. Named series winners, they became regulars on *Scene at 6.30* to an audience of nineteen million and major recording artists on Decca records.

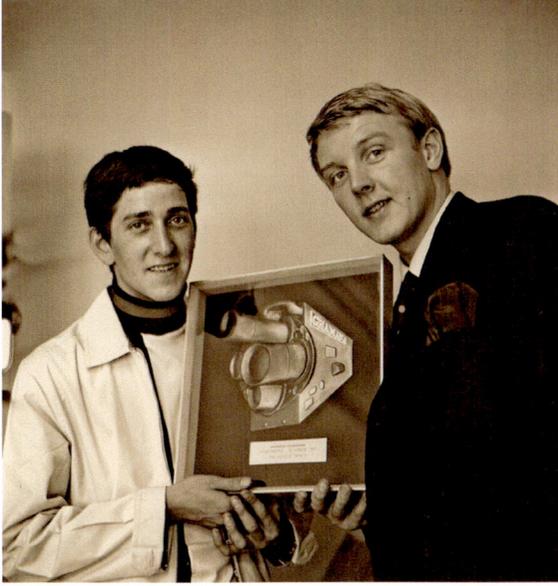

With over 500 radio and TV programmes The Foggy Dew-O had their own BBC radio 2 series – *My Kinda Folk*. They released three albums and six singles and were about to do a new BBC2 show when Lennie was diagnosed with a rare lung disease in November 1968. Off the scene for over a year and just missing the fame that was in their grasp, a disenchanted Lennie decided to finish in December 1973. Danny continued as Foggy with Rob from Liverpool, becoming more folk entertainers and songwriters and resumed painting from his gallery in Cawthorne.

Half of the Walker Brothers, John was among the top stars who appeared at the Civic in 1969. The brothers played the Staincross WMC back in November 1966. In November 1970 the question was, why do major bands in vogue in the early 1970s bypass Barnsley? However, in 1966 The Who played at the Civic. In October 1969 a Civic advert read, 'Don't miss The Small Faces' who appeared with American band 'Canned Heat' who were on their first European tour. The MC was Dave Lee Travis.

Billy J. Kramer was just passing through Barnsley station in June 1967. The sixties star was produced by Beatles legend George Martin, whose song 'Theme One' was the first heard on Radio One and was a hit for Van Der Graf Generator who played at the Civic Hall along with the Pretty Things. Other sixties stars who played in Barnsley included Billy Fury, Cockney rhyming slang child star Ruby Murray, reggae original Desmond Dekker and tip-toeing falsetto Tiny Tim.

The Monk Bretton Social Club on Lamb Lane was erected in 1965 by the Coal Industry Social Welfare Organisation (CISWO). The club had 2,000 members, a cabaret room with 650 capacity, lounge bars, restaurant and bowling alley. After the closure of the Monk Bretton Colliery, it was taken over by the Bailey Organisation and renamed the New Monk Bretton. Stars of the day played three-night stints but in 1974 it became 'the Londoner', which closed in the early 1980s and the venue is now a fading memory.

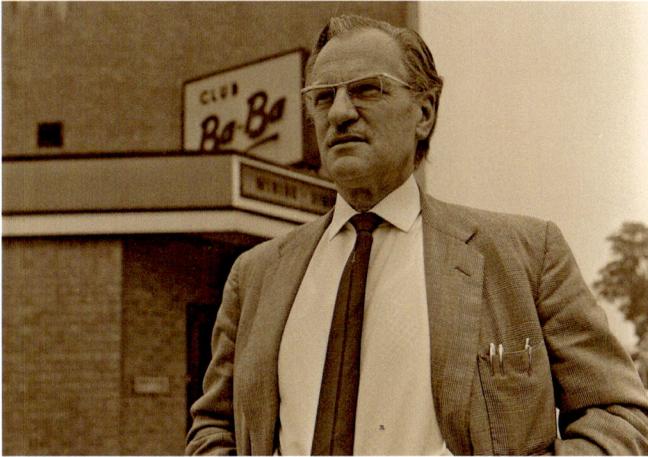

Club Ba Ba had joint owners Jack Lister and Peter Casson, who threatened to report the Gambling Board to the Race Relations Board for discrimination against 'Yorkshiremen'. Barnsley wasn't designated as a place where gambling would be permitted. Casson, who declared the gambling ban was against the Magna Carta, replaced roulette wheels in the club's casino with a game he had invented. For a shilling stake winners won vouchers worth a maximum of 18s, to use in the bar, restaurant or to get a prize.

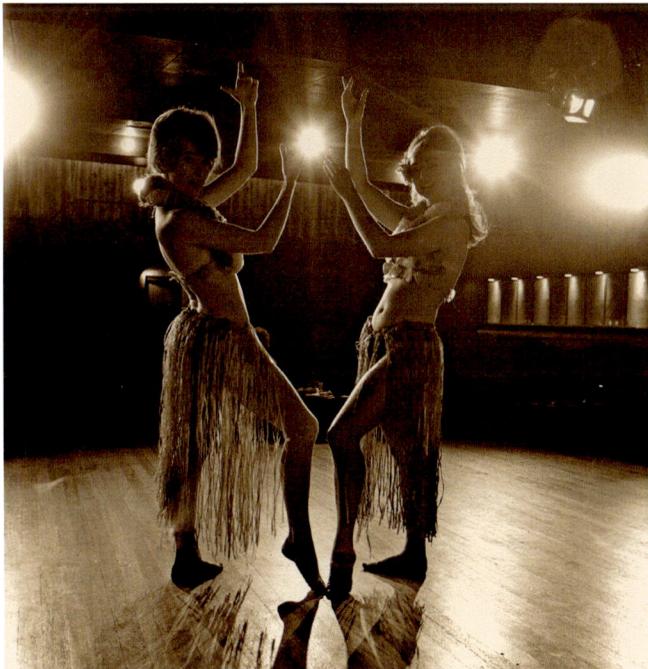

The police wanted Club Ba Ba's special hours granted in July 1967 to provide live music and dancing revoked. The police visited the premises eight times and found only gambling and drinking and no music or dancing. Jack Lister said changes were taking place to comply with the licence. However, in April 1969 the club faced prosecution and admitted if roulette, craps, black jack and the wheel of fortune were played in the normal way the chances were not equally favourable to all players.

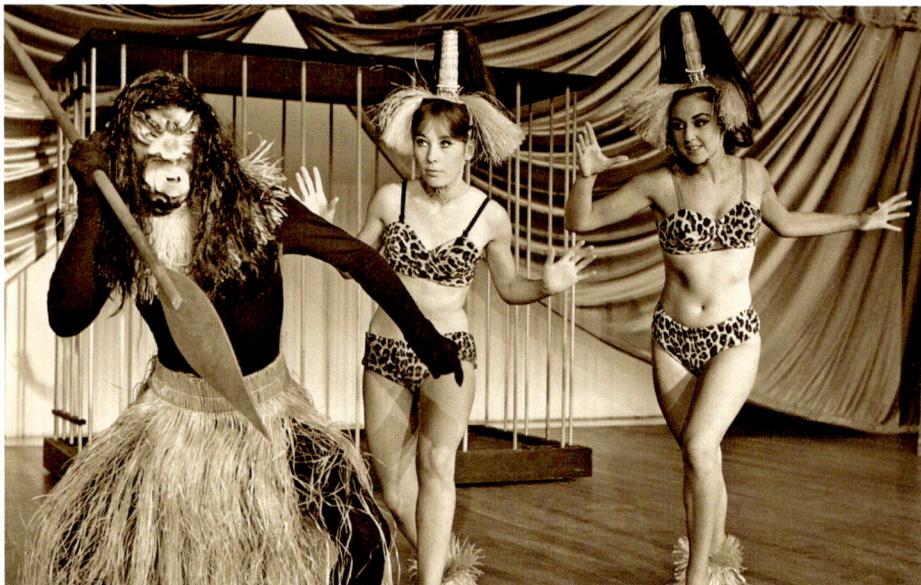

A court case against Club Ba Ba was adjourned when Peter Casson required surgery at Beckett Hospital for a broken leg after slipping in the snow. Meanwhile the Club's new manager, Christopher Evans, was improving the visual aspects of the club. One of the youngest nightclub managers in the country, the Royston miner's son had designed costumes for *Doctor Who* and *Out of This World* at the BBC. Evans said younger people wanted more sophistication and he aimed to make the club really swing.

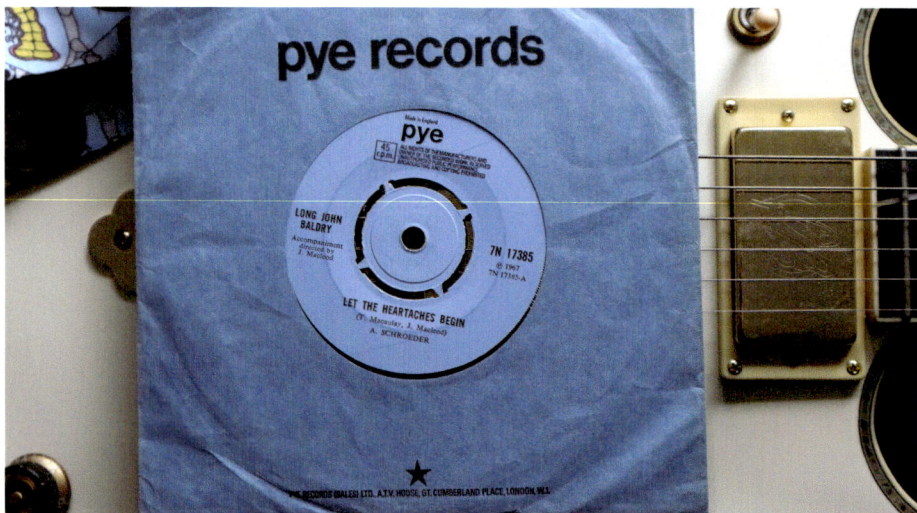

Stars to play at these two Barnsley clubs included Eurovision winners Lulu and Dana, and artists with number one hits including Long John Baldry ('Let the Heartaches Begin'), The Scaffold ('Lily the Pink'), Christie ('Yellow River') and The Tremeloes ('Silence is Golden'). Top five band Roy Wood's the Move ('Flowers in the Rain') and members of famous bands Michael Naismith of the Monkees and Alan Price of the Animals appeared. Television stars included Mike Yarwood, Bob Monkhouse, Freddie 'parrot face' Davies and Les Dawson, who warned that club-based entertainment had reached its peak and was beginning to drop off.

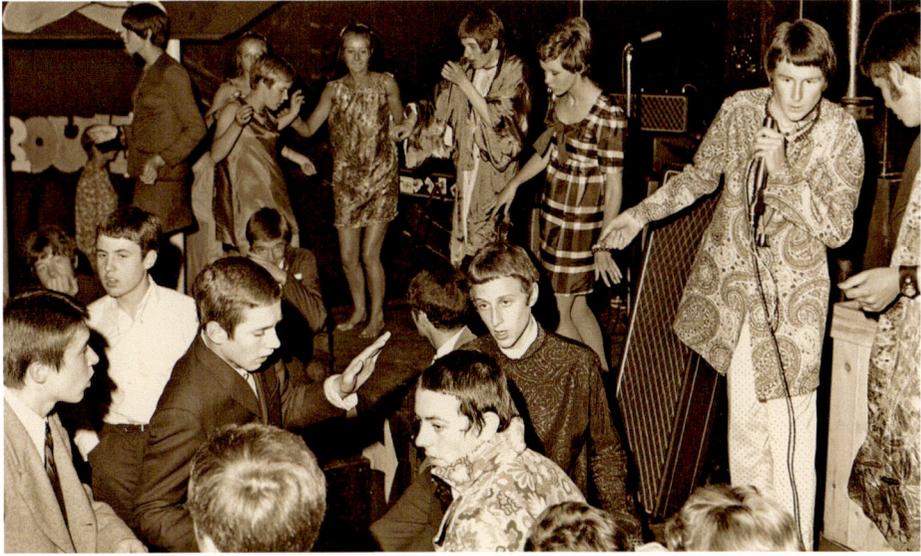

The Hub on Peel Street advert said 'Go where the crowds go'. Every Friday night Peter Stringfellow, the resident disc jockey, was calling himself 'The Greatest DJ of them all'. He owned the King Mojo Club in Sheffield and managed local band The Chicago Line, whose first single was called 'Shimmy Shimmy Ko-Ko Bop'. Other local bands featured included Ellison's Phonograph and Top Soul Tamla Group. The Lemon Line recorded 'For Your Precious Love' and Barnsley's greatest group was 'Shock Treatment'.

This picture was taken in the Market Inn, one of many public houses that were demolished. In 1967 one of the oldest pubs in the north of England, 'The Bridge' at Darfield, fell prey to subsidence. In 1970 'The Old Warrior' on Sheffield Road disappeared along with the Ebenezer Church. The Norman Inn, Monk Bretton, demolition revealed an 1888 newspaper article about Dr William Burke. He'd had an affair, got very dunk before meeting his wife on the premises with his daughter Aileen who he then shot before shooting himself.

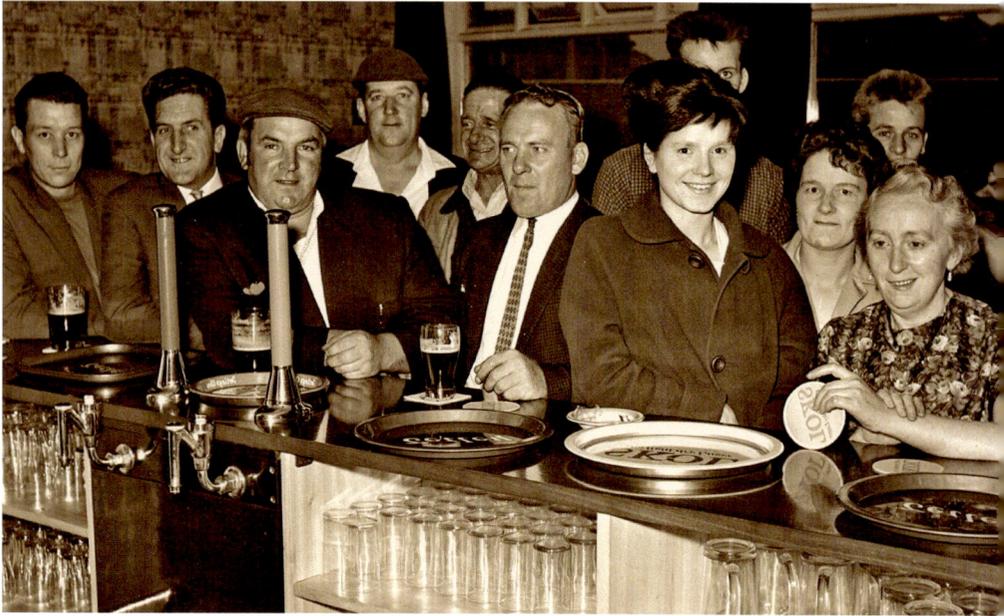

This is last orders at the Wellington Hotel just prior to its demolition in 1962. On 6 June 1970 gallons of beer costing 1s a pint were drunk for the last time at Carlton Main WMC on Long Row. The Wharncliffe Woodmoor colliery would soon close and the hundred mining cottages which used to provide customers had long since gone. The club, where prior to 1929 women were not admitted and all men had to be smartly dressed, had organised annual trips to Scarborough.

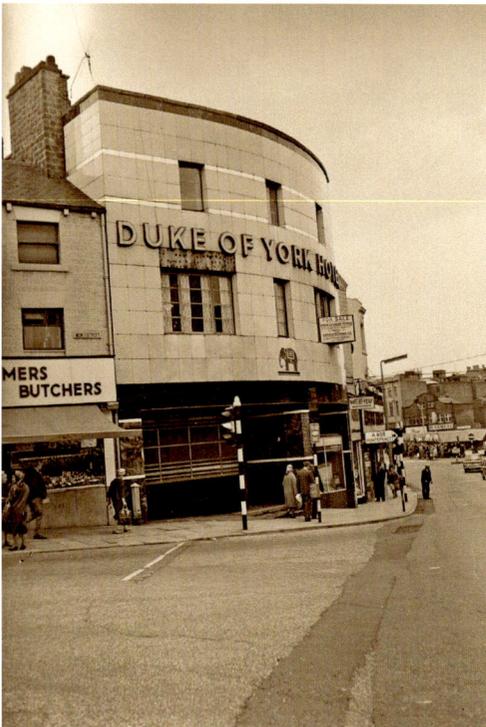

In August 1968 the Duke of York on Cheapside was put up for sale. The pub, dating from 1876, was originally owned by Clarkson's Old Brewery which was founded in 1839 but closed down in 1956. The company was briefly reformed in Cleckheaton between May 2006 and May 2011. The Marquis of Granby was another pub named after an eighteenth-century war hero. The nineteenth-century public house on Thomas Street was in the 'Barebones'. The pub was left stranded when the workers' houses were demolished around it.

Another Clarkson's pub dating from 1887 was purchased by Barnsley Council expressly so it could be demolished to improve the vista viewed from the Barnsley Interchange. The Devonshire Arms occupied a prominent corner at the acute junction of Midland Street and Eldon Street. It features on many old photographs that illustrated its critical contribution to the appeal of this part of the town. The historic street pattern reflected by the narrow frontage at the corner is now crudely truncated.

The former Keresforth Hall Country Club held private functions and this was a slave market. Now a private house, Barnsley FC celebrated after winning promotion at Keresforth Hall. Saturday and Sunday dinner dances featured the Johnny Johnson Quintet. BBC weatherman Bert Foord spoke at the club. He was introduced by Mrs M. Tasker, Chairperson of the Barnsley Club. Mr Foord explained the first shipping forecast was sent by telegraph after the government lost a lot of ships and wanted to prepare for storms at sea.

The Bonanza Club met at Keresforth Hall and was one of many local societies to use the 'Old Hall' that became a country club in June 1966. However, soon headlines were of nearby residents complaining about bedlam in the small hours. In 1970 a French chef, Sir M. Antione, took over the club. He had cooked in Paris hotels and served Gracie Fields and the Agha Khan. Whilst in the French Resistance he was arrested four times by the Gestapo, but managed to escape each time.

Tony Evans' established his career playing saxophone at the Race Street Baths in The Geoff Haigh Trio. He became a renowned band leader who recorded concerts on the BBC and released many records. He formed his own band, playing first at the Harborough Hills WMC and then the Three Cranes Hotel. Tony established himself as a big-name band leader by replacing Joe Loss at the Empire Ballroom in Leicester Square and enjoyed a long run at the Hammersmith Palais De Danse. He was musical director for Mary Hopkins.

Grimethorpe Colliery Band were named 1967 Open Champions of Great Britain. In November 1970 they became the first colliery band to win the title of Champion Band of Great Britain. Conducted by George Thompson, they appeared at the Civic Hall and released *Belle Vue Brass* on Pye records in 1968. In November 1970 they were back at the Civic along with pianist and composer Semprini whose BBC radio *Serenade* series ran for twenty-five years.

Theatre and Cinema

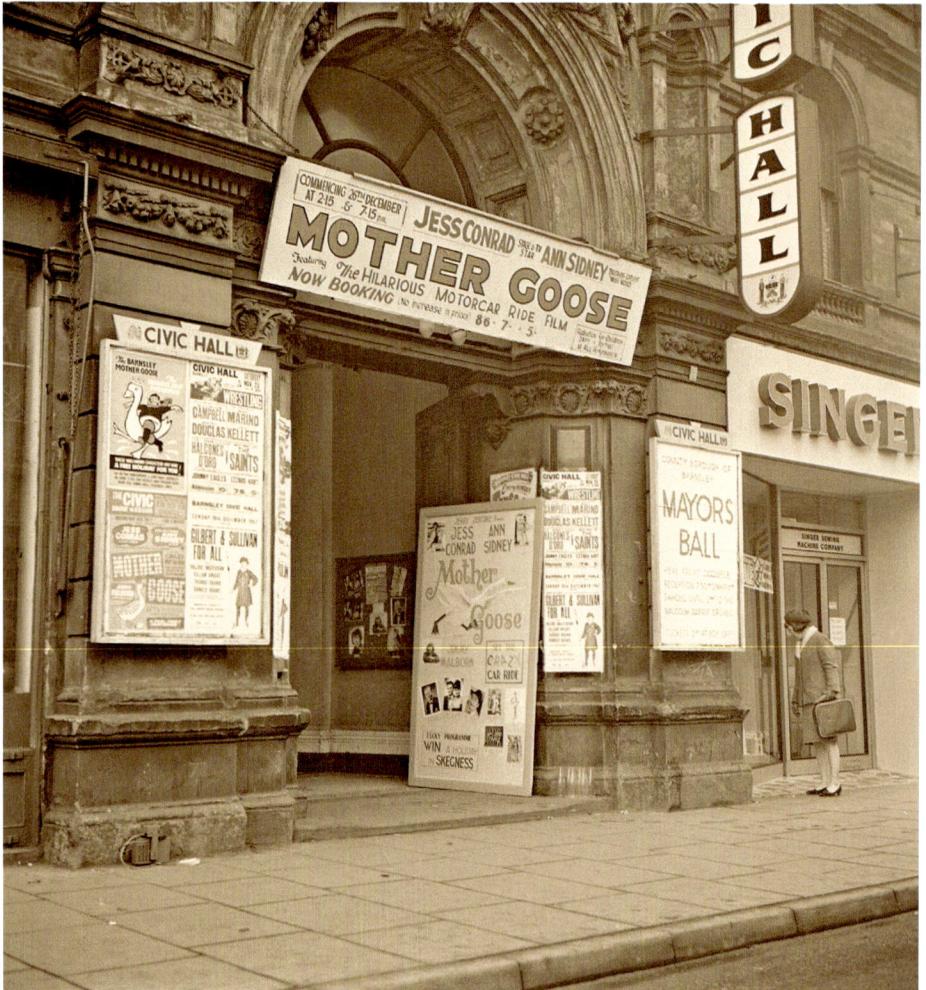

In 1968 there were plans to turn the Civic Hall into a 'vast entertainment complex'. The main theatre had a £1,800 facelift and it was said the former ground-floor library could become a dance floor. The unused headquarters of the Barnsley Museum, which moved to Cannon Hall, became the Centenary Rooms to bring in a younger audience. Barnsley Brewery Co. donated the bar and dance floor from the Three Cranes Hotel to create the 'Old Barnsley Bar' with ancient beams and old Music Hall posters on the walls.

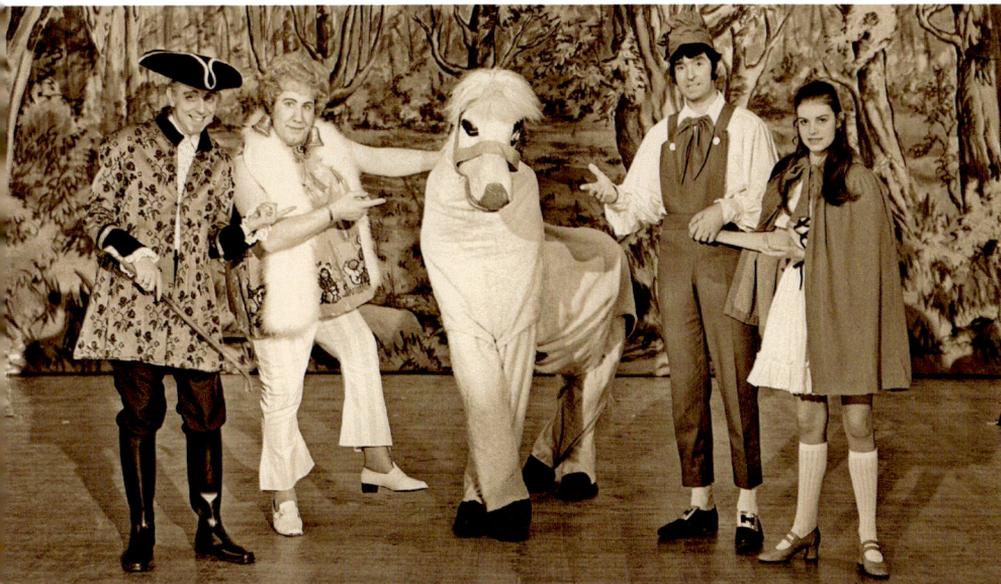

After the war there had been no pantomimes at the Civic. In 1966 only the third annual panto was *Snow White and the Seven Dwarfs* starring Charlie Chester. Ticket sales were double compared to the previous year. Coach parties had been arranged from all over Yorkshire and Lincolnshire. Landscape artist Ashley Jackson painted all of the scenery for the production. It was his first time doing theatrical work and was made more complicated because it was cartoon style.

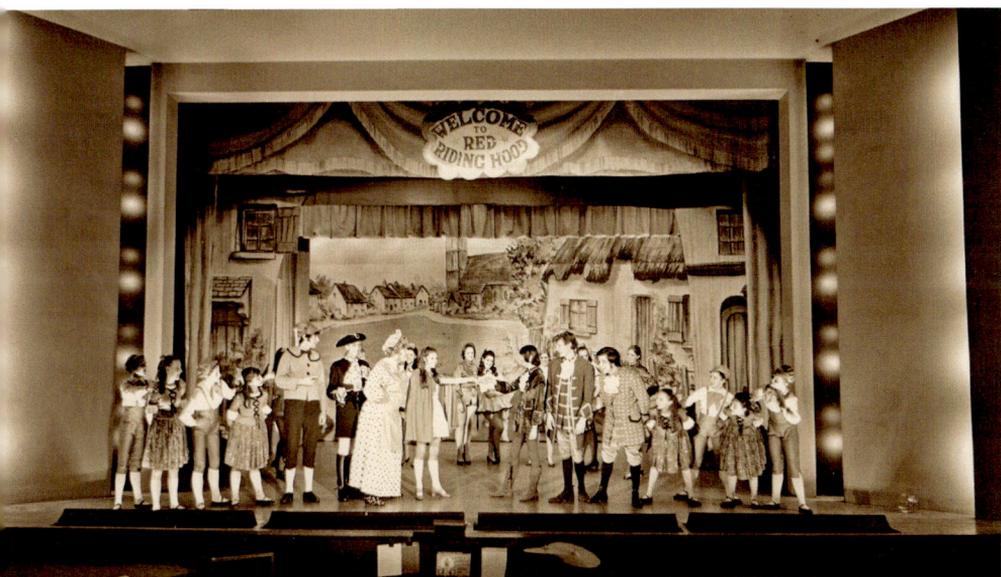

The pantomime in 1970 was *Red Riding Hood* starring Clinton Ford and stand-up comedian Ken Goodwin who had played the New Monk Bretton in May 1970. Finding another actor with the same name after playing Billy Casper in *Kes*, David Bradley became Dai. Dai Bradley was the woodman's son and Kathryn Jones Red Riding Hood. Although still at St Helen's School, Bradley already had many offers of work. The panto's publicity told people to watch Dai every Sunday on Yorkshire TV's *The Flaxton Boys*.

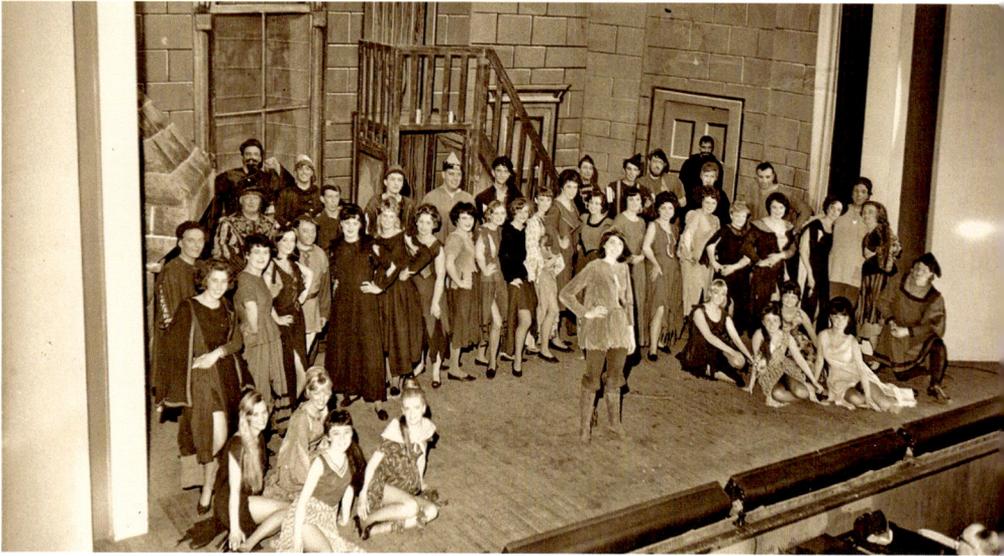

It was not just pantomime; this was the *Vagabond King* in 1967. In the same year the show *Lock Up Your Daughters* was a bawdy musical based on the love comedy *Rape Upon Rape* by Henry Fielding. Arthur Lowe, Coronation Street's Leonard Swindley, played the corrupt Justice Mr Squeezum. The 1970 all-male revue *Glad Drag Dolls* played to modest audiences. The *Chronicle* opined that Barnsley people simply didn't go for this type of entertainment. However, as a sign of the times the 'record-breaking' Minstrel Show was a hit at the Civic in 1968.

In March 1969 the Barnsley Operatic Society celebrated its fifteenth year with Irving Berlin's *Annie Get Your Gun*. A year later the attendance for the *King's Rhapsody* by Ivor Novello at the Civic was disappointing. When it was found £12,000 would have to come from the rates to cover Civic theatre losses, councillors who had supported the arts baulked. An editorial called out fickle audiences. When the public complained about being starved of culture, they had a duty to make the effort to actually show up.

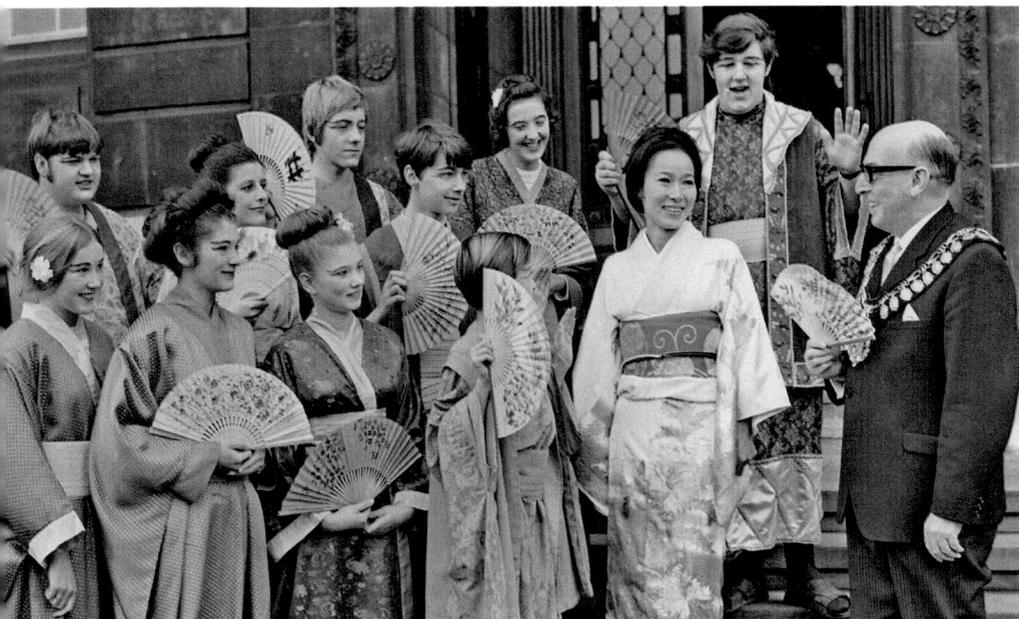

There were many amateur productions. The Barnsley Junior Operatic and Dramatic Society performed the *Mikado* at the Technical College. Mayor Frank Crow was pictured with the cast and Mrs Yoko Miller, a Japanese woman who lived in Barnsley. The *Desert Song* was performed at the Civic by the Wombwell and District Amateur Operatic Society. Professional singer Louise Kenton of Yorkshire Opera who sang at the Investiture of the Prince of Wales at Caernarfon Castle performed extracts from *La Boheme* with Birdwell-born David Fieldsend.

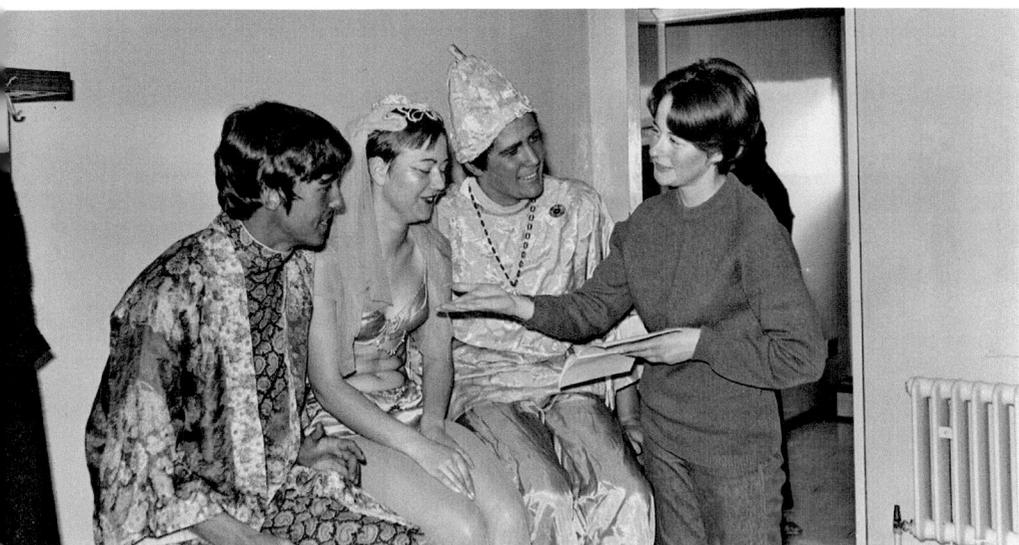

This picture shows the sixth annual festival of the Barnsley and District Amateur Theatre Guild held in July 1967. The festival comprised of a series of one-act plays held at the hall of the College of Technology. Amongst the theatrical societies' productions was Terence Rattigan's *Separate Tables* under the banner *Drama 64*. The theatrical tradition bore fruit in 1966 when Barnsley actor Kristine Howarth took the lead role in BBC2 series *Lord Ringo* after appearing in *Dixon of Dock Green*.

Mavis Burroughs School of Dancing provided support for many of the town's productions including the YMCA Operatic Society performance of Offenbach's opera *La Belle Helene* at the Civic with Christina Matthews in the title role. The *Chronicle* described the pupils of the school of dancing as a near-professional troupe. It was claimed Barnsley had the best Dance Festival in the country and in 1966 the well-known choreographer Robert Harrold judged the festival and said some performances were as good, if not better, than you would see on the West End.

For twenty-one years the Barnsley Orchestral Society brought many internationally renowned soloists to Barnsley audiences, but in 1970 the suspension of the society's activities was announced. The orchestra had only eighteen Barnsley-based players, which was unsustainable. In 1970 the soloist was Sheffield-based Sri Lankan Rohan De Saram, described as one of the most gifted cellists of his generation by Pablo Casals. In 1969 Manchester-born violinist Raymond Cohen played at the Arcadian Hall. Cohen was the first soloist to play on the BBC.

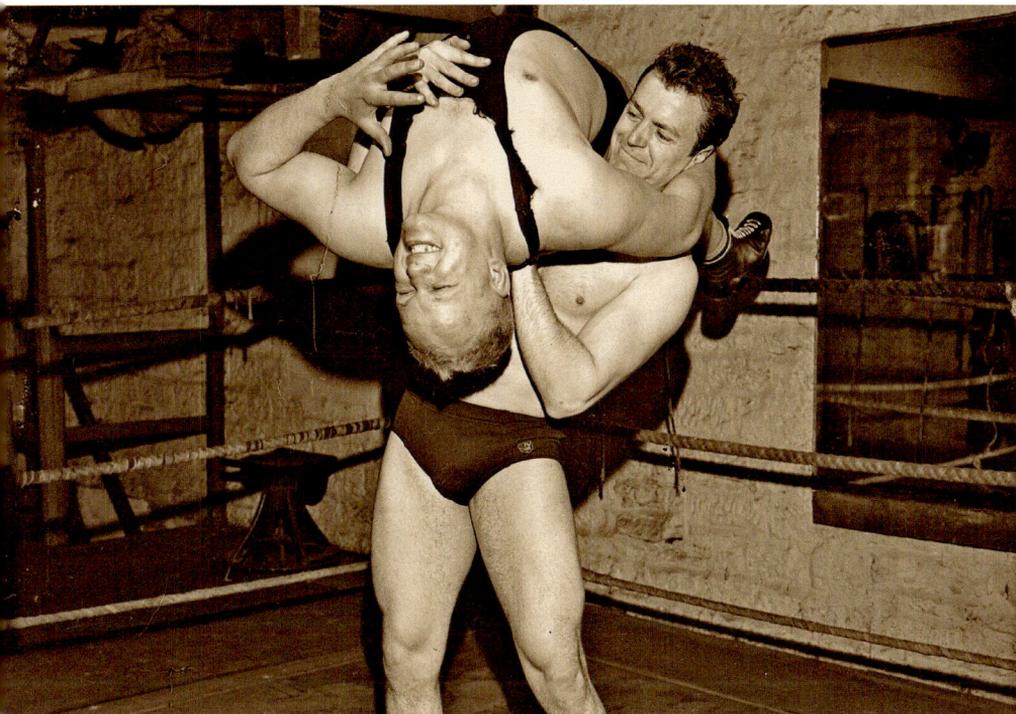

On 28 September 1968 wrestling was televised in the recently redecorated theatre. Jimmy Savile revealed his 'other side', according to reports, and Brian Glover was thrilled to top the bill after being a supporting bout wrestler for fourteen years. His father, Charlie Glover, ran a gym on Quarry Street. Glover, who learned to wrestle at the gym, was in the Barnsley Boys football team which won the English School Trophy and Yorkshire Shield in 1948–49. Brian acquired his wrestling name when he substituted for Frenchman Leon Arras.

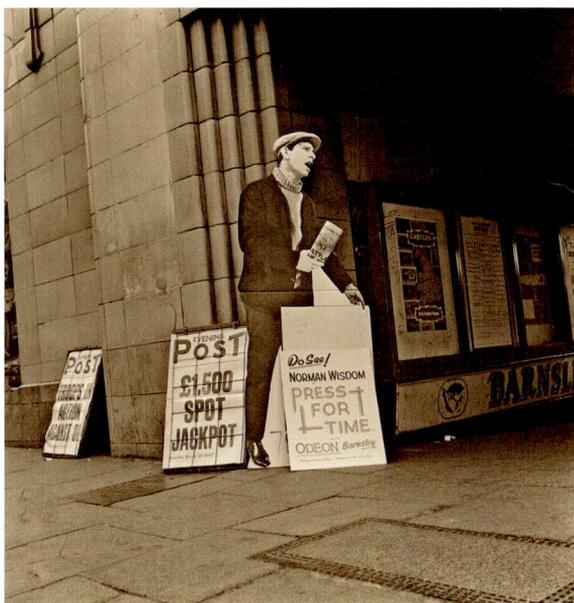

Barnsley's first purpose-built cinema, the Barnsley Electric Theatre, was opened in Eastgate in 1911. Another of Barnsley's purpose-built cinemas was the Globe Picture House, which opened in 1914. In the 1930s impressive cinema buildings like the art deco-style Ritz Cinema appeared. The Ritz Wurlitzer was first played in 1937 by Ernest Exley during the interval and for communal singing with lyrics displayed on the big screen. In October 1968 the Ritz Wurlitzer organ was sold to a Lincoln-based cinema owner.

Many of these cinemas closed, including the Electric Theatre (1938) and the Cosy Cinema (1928), Pavilion (1950), Princess Palace (1956), Britannia (1959), Alhambra (1960) and the Globe Picture House (1962). In 1966 having a new cinema within the town centre redevelopment was criticised by the Cooperative, who pointed out the current trend for live entertainment in working men's clubs. Barnsley used to support seven cinemas but then there were two. In 1961 the Ritz became the ABC, which closed in 1974.

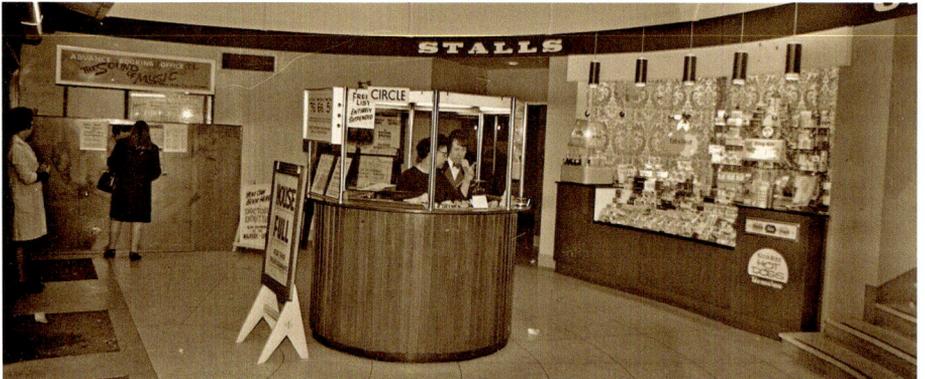

The other main cinema, the Odeon, was on Eldon Street. Originally called the Empire Palace, it was a highly decorative converted theatre. It was renamed the Gaumont Cinema but was gutted by fire in January 1954. The Gaumont was rebuilt to a less festooned modern design and reopened in 1956. The building was renamed Odeon in 1962, but closed in 2005. The refurbished and modernised Parkway Cinema opened in 2007 and was the only cinema in town until Cineworld arrived.

Arthur Seddon's office walls were covered with photographs of the stars he had met. He thought showmanship was part of being the ABC Cinema manager. Born in Grimsby, he moved to Barnsley in 1960. He met his wife on Christmas Eve at a hospital charity event attended by Dickie Bird and Dorothy Hyman. He is seen at the ABC Minors Club Poncho contest part of the Saturday morning showing of British Film Foundation productions. In September 1970 Seddon was the guest of honour at the ABC awards in London.

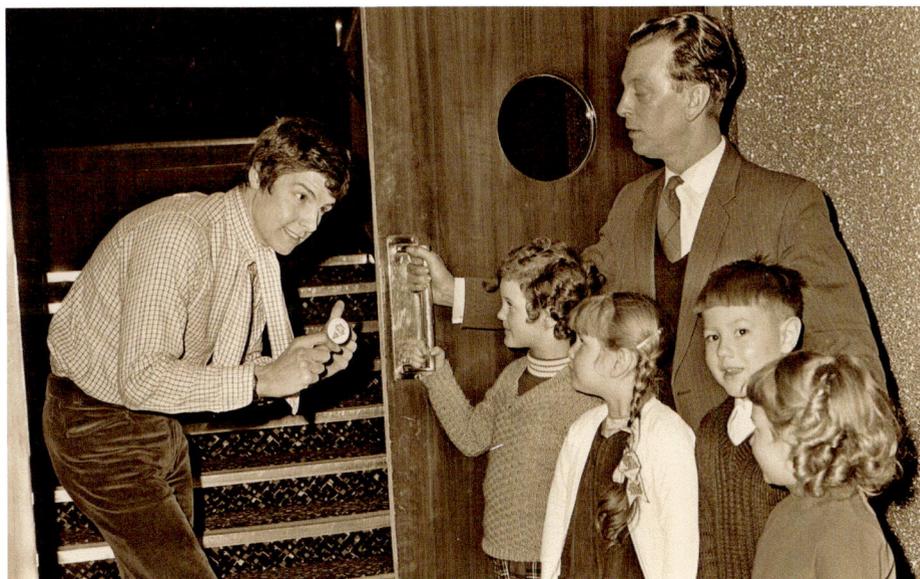

Mother Goose star Jess Conrad is pictured with the ABC manager. Arthur Seddon had spent years developing a pub game. Six plywood horses raced over a 27-foot-long course using pulleys. Armed with a duffle coat toggle in each hand, participants vigorously moved horses attached to a sturdy metal base with castors whist listening to a pre-recorded commentary. Only ex-servicemen had played due to the stamina needed. At the unveiling ceremony at the Halfway House Seddon said everyone loved it but it would have to come down soon because the pub couldn't spare the space any longer.

United Artists insisted no slight was intended to Barnsley when *Kes* opened in Doncaster. This was in a letter given far less prominence than *Kes* producer Tony Garnett saying his personal first night would be in Barnsley on Sunday 29 March 1970. To prove the point director Ken Loach, stars of the film and camera crew attended. Over 6,000 people a day went to the ABC to see the film. A spokesperson for ABC said they were more popular than Barnsley FC as queues stretched all the way to Town End.

Above is a St Helen's School pantomime from 1968. *Kes* stars were mostly pupils of this secondary school. A *Kestrel for a Knave* author Barry Hines taught here and David Bradley's acting experience started in the school pantomime. Bradley played Danny Dumpty in *Red Riding Hood* in 1969. He previously played Sinbad the Sailor and was Charlie Dimple in *The Piper of Troon*. His on-screen brother Freddie Fletcher lived in Grimethorpe and worked as a painter and decorator before he got the part in *Kes*. After filming he went back to work at, this time, Grimethorpe Colliery.

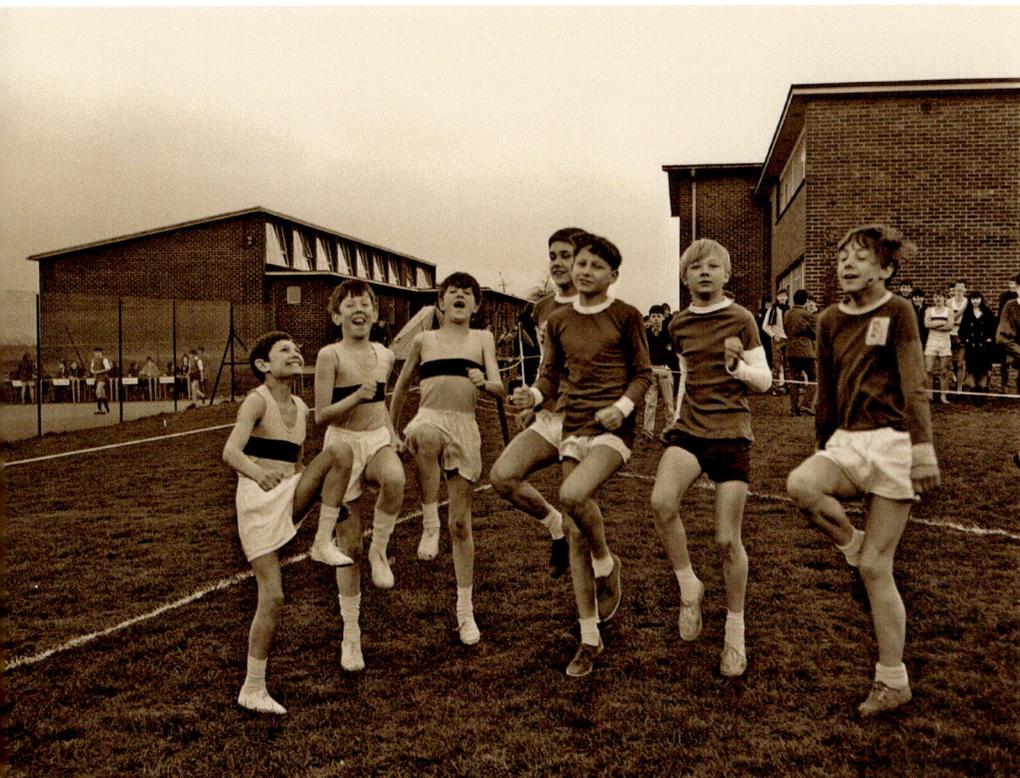

Barnsley school cross country 1968 looks as cold as the football scene in *Kes*, which was back for another week in August, taking the total to four weeks. However, the RSPB wanted an on-screen warning because children had started catching and training kestrels, which was illegal without a falconry licence. A *Kes* art competition invited children to colour in a line drawing based on a scene from the film. Meanwhile David Bradley was back at school taking rearranged CSE and GCSE exams and Freddie Fletcher landed his first TV role in *Queenie's Castle* starring Diana Dors and Lynne Perrie.

Famous People and Local Characters

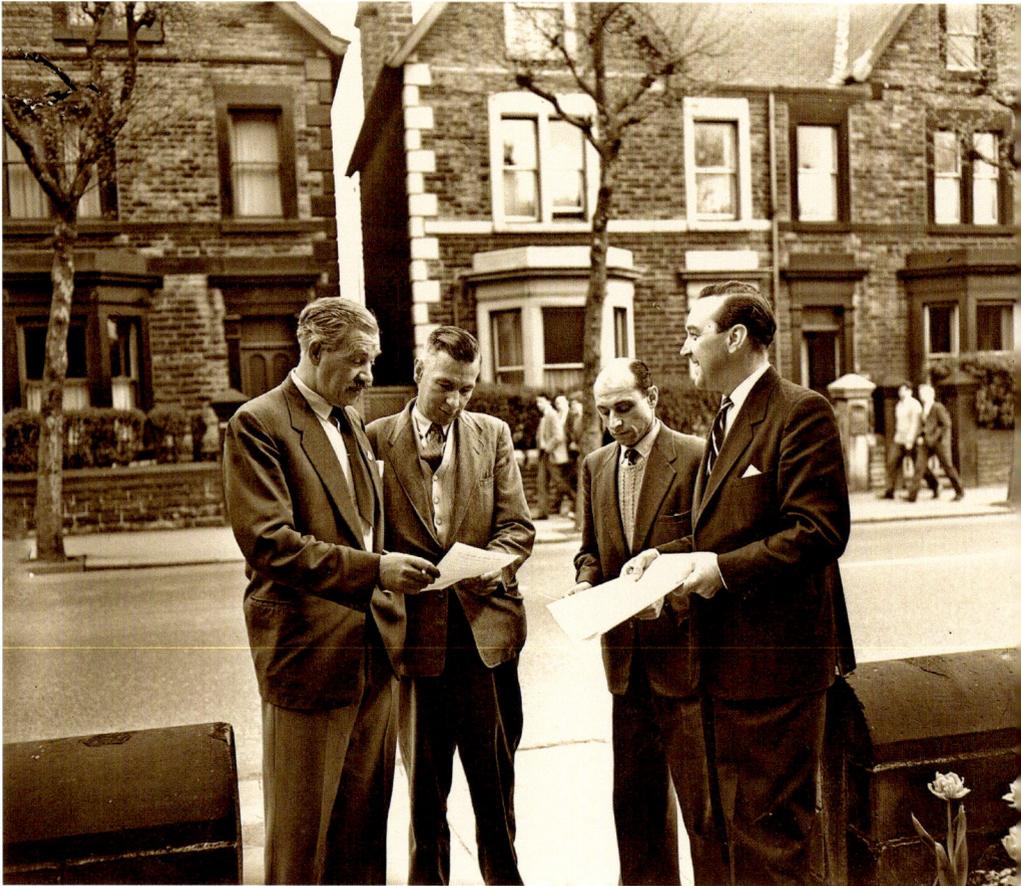

Barnsley MP Roy Mason is pictured outside the NUM offices in April 1961. In August 1968 Roy Mason met with septuagenarian Ken Lee, his first overman. Before becoming an MP Roy Mason worked as a fitter at Wharncliffe Woodmoor Colliery. By February 1969 as Minister of Power, Mason decided the future of his old pit. Prior to closure Mason asked Ashley Jackson to paint the pit for sentimental reasons.

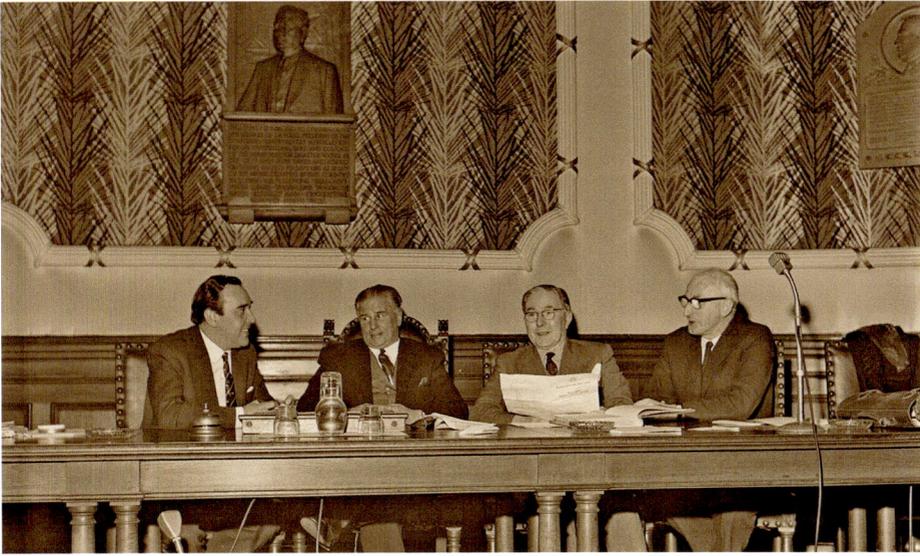

Roy Mason is shown at a meeting in the Miners Hall. Before leaving the Ministry of Power he flew by helicopter from Barnsley's Queens Ground to Kingsbury to open the first United Kingdom oil pipeline, which was seen as a fundamental threat to the coal industry. In 1970 he found himself in opposition and made a speech in Parliament about the future of coal mining. He said morale in the industry was at rock bottom. Despite their co-operation miners' wages had slumped below those of almost any other industrial worker.

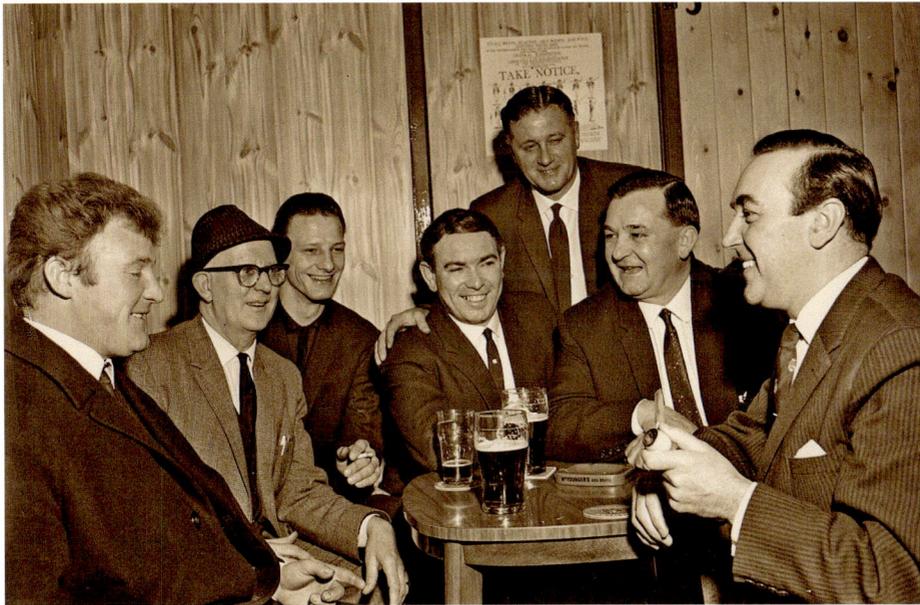

Roy Mason was blamed for Labour's surprise election defeat in 1970 when they lost seventy-five seats. Lord Balogh, an economic advisor to the government, pointed to the import of two useless and immobilised jumbo jets that could not be used because of a trade dispute. Roy Mason accused the Lord of not knowing the facts and said to cancel the deal before the election would have been interpreted as 'cooking the books', which would have had a worse impact on the election.

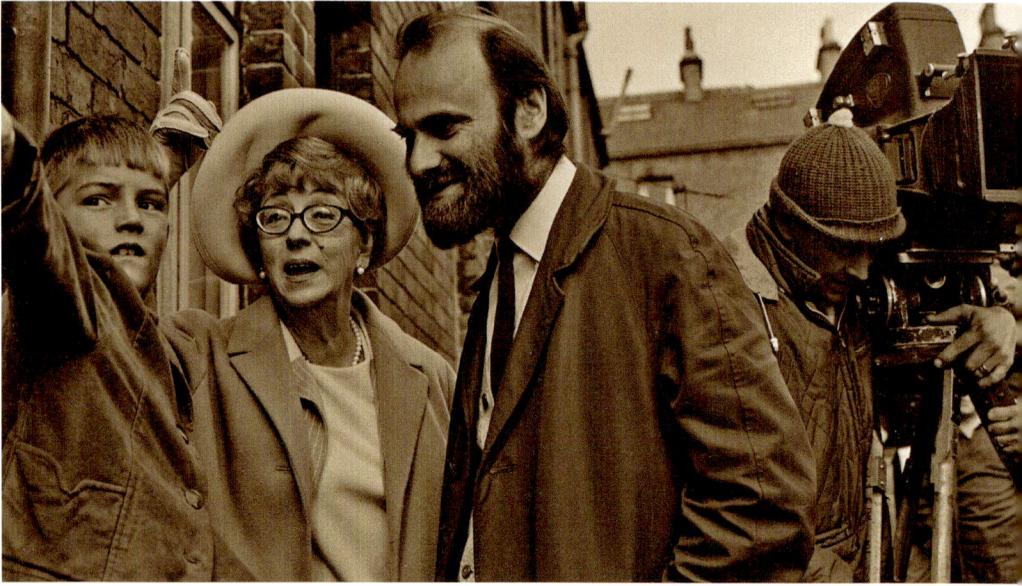

Thora Hird is pictured filming on Canal Street for new political drama *The First Lady* in September 1967. Parts of the Town Hall were also featured in the show, which was about local government in a fictional town called Furness. There were two critically acclaimed series written by Alan Plater. Thora Hird's character Sarah Danby was loosely based on Barbara Castle, who was the transport minister responsible for introducing speeds limits, the breathalyser and compulsory seat belts.

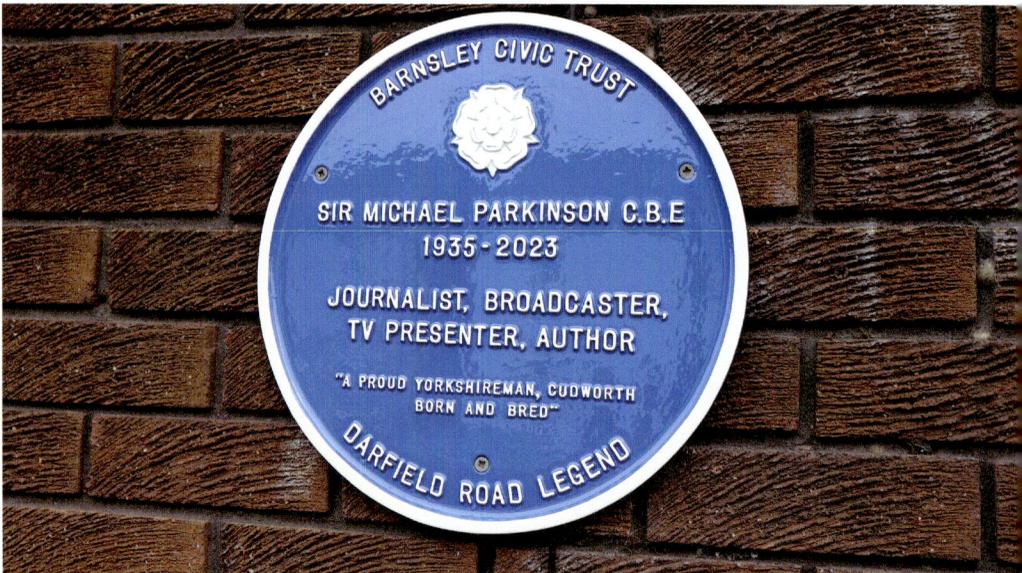

This blue plaque was placed at the Dorothy Hyman Stadium, Cudworth, in October 2023. In 1970 Michael Parkinson was presenting Granada TV's *Cinema* and writing for the *Sunday Times* and *Punch*. After starting at the *Chronicle*, he had written about the Barnsley Chop, the Bus Station Café and uncompromising Barnsley footballer Skinner Normanton. 'Mike' Parkinson guested at Raley School speech day saying he had 'come to earn some bread' despite being the worst pupil at school, only winning a prize for having the biggest feet.

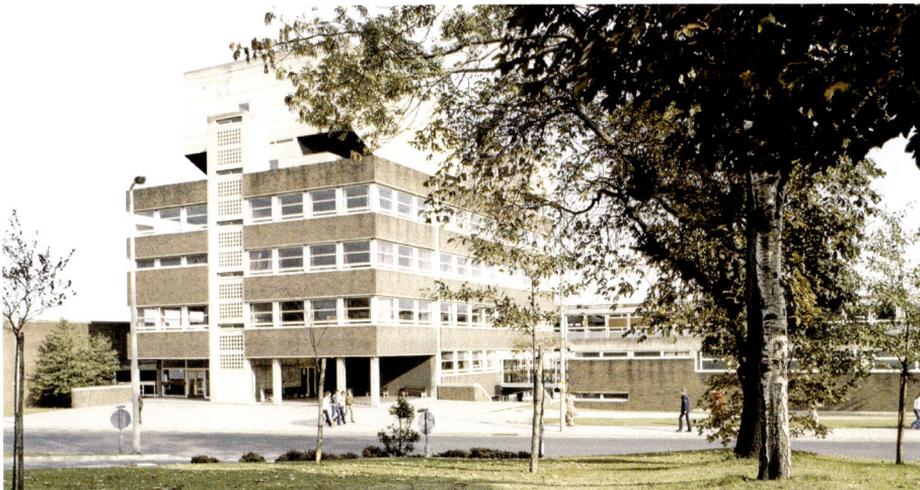

Mountaineer Chris Bonington appeared at the Technical College in November 1969. In October 1970 Gordon Hibberd of Redbrook needed permission to attempt the highest unclimbed peak in the world, Gasherbrum III in the Karakoram range. It would be climbed for the first time in 1975. Despite this in 1967 Hibberd had been part of a three-man team making the first accent of the Fortress Mountain in Chile and was the first Briton (and second in the world) to solo climb the north face of the Eiger.

One of TV's biggest stars Val Doonican, who had friends living in Kendray, was a regular visitor to St Joseph's on Doncaster Road. In May 1967 he opened the Whit Monday Gala at St Joseph's which made headlines for completely different reasons in September 1989. Following the murder of a police inspector at M62 Birch services, convicted armed robber Tony Hughes killed himself in the priest's garage when surrounded by police. Both the church and school were subsequently demolished.

Technical College art students are in a town that produced famous and lesser-known artists. James Badics used his cellar as a studio, where he produced a highly controversial piece of public art for Rawmarsh called *Resurrection*. Barbara Girdlestone took up painting aged forty-seven but became one of South Yorkshire's most celebrated artists with exhibitions at the Royal Society of Arts and the Royal Watercolour Society. Tommy Sibley started painting with his mouth at school and aged fifty-four two of his pictures were on display at Lundwood Hospital.

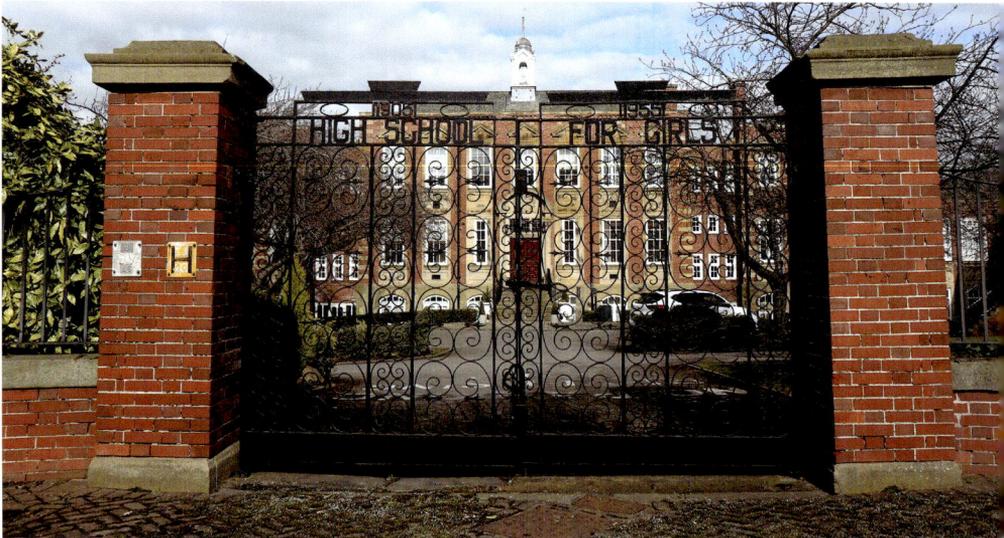

Unveiled by Lord Louis Mountbatten in October 1968, a Brenda Bury painting of the Queen at Buckingham Palace hangs in the Great Gallery Pall Mall. Bury was born in Brierley and went to Barnsley High School. An early portrait of Colonel Rowland Addy, who lived at the former Brierley Hall, hung in the Cooper Gallery and a painting of Mayor Alderman McVie is in Barnsley Archives. Brenda also painted Lord Mountbatten and politicians Margaret Thatcher, Tony Benn and Lord Hailsham.

In January 1969 Ashley Jackson embarked on 'an emotional experience of a lifetime' aboard the trawler *Conjuan*. The trip that would inspire some large-scale watercolour paintings of scenes at sea which were probably displayed in his town centre shop only lasted two days. The captain abandoned the five-day voyage into Icelandic seas due to terrible weather conditions that showed 'nature in the raw'. Jackson described waves as high as houses and the crew being tossed around like ping pong balls. He said due to freezing temperatures the water was crashing over the deck like an ice shower.

Col J. G. E. Rideal, who was Chairman of the Housing Committee, lived on Sackville Street. He had a distinguished service record during the First World War and was the Commander of Barnsley's Home Guard. In 1943 he was given the Freedom of Barnsley. His wife, Else, an army nurse based in Egypt, was a founder member of the women's section of the British Legion. Before the foundation of the NHS, she was on the Health Committee of the Barnsley Corporation and later served on the Management Committee of Beckett Hospital.

Rita Briton founded a high-end boutique called Pollyanna in a small shop on Shambles Street in 1967. The business became internationally recognised for stocking fashion by top designers as well as Rita's own Nomad label. In 1998 Pollyanna was one of a handful of shops worldwide allowed by Yohji Yamamoto to stock his exclusive Y collection and the shop landed in a more prestigious location with a café on George Yard. Rita also received funding towards a fashion design centre on Shambles Street. Pollyanna closed in 2014.

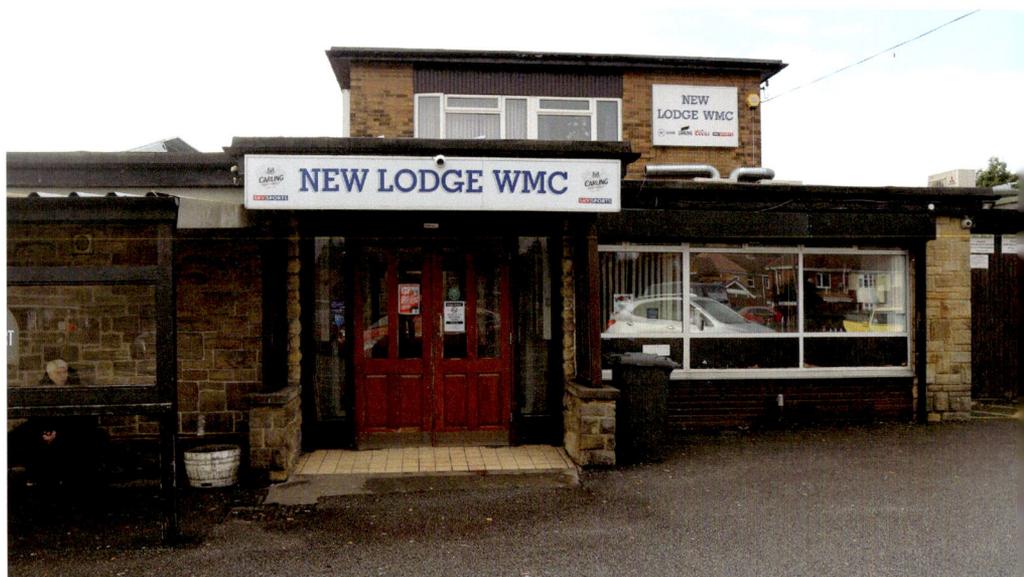

Reg Rapson was a celebrated drummer who became a band leader whilst working for the Department of Productivity on York Street. Reg, who also played the piano and violin, started out at the Majestic in Wembley before his own band, the Georgians, played at the opening of the Barnsley baths in 1927. In his pomp he provided the rhythm section for Phil Thompson's band that were better known as the Ambassadors. After the baths closed, he played with an organist every Tuesday night at the New Lodge WMC.

In August 1967 David Beedon and Peter Lawford embarked upon a twelve-day 3,769-mile coastal drive around Britain. Another motor enthusiast was car mechanic Mick Chatterton. In 1969 he was placed sixteenth in the World Championship for motorcycle road racing. The Motorcycle News website had a feature on Mike who, aged seventy-two, was still competing in the Isle of Man TT Races. He was being interviewed at his house in Barnsley. He had only missed one year at the Isle of Man since 1964 when it was cancelled due to foot and mouth disease.

Lionel Robinson is showing off his muscles bending a piece of metal in September 1970. In November 1966 farrier Cyril Cooper had a blacksmith's workshop called Town End Forge on Peel Street. This was on the site of a workshop where horse-drawn carriages were made. There were no carthorses, so his business was mostly riding school horses and ponies. Cyril wanted to be a motor racing driver and had trials at Brands Hatch, but decided he could not combine two occupations.

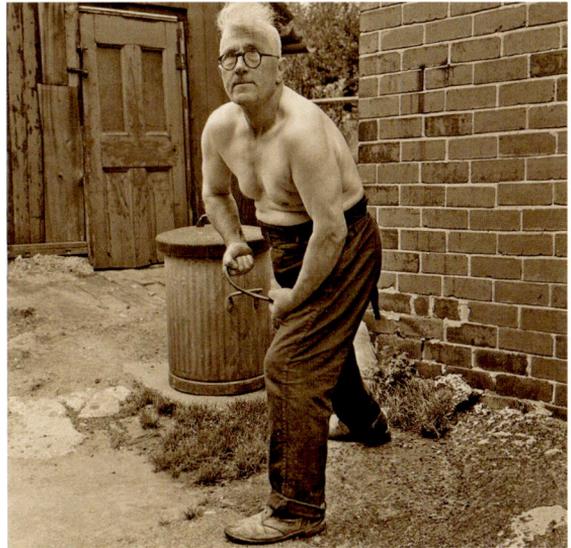

In 1967 Arthur Smith is showing off his impressive collection of bottles. In May 1969 it was reported that John Luckarift, a sixty-year-old clerk living on Gawber Road, was the UK's leading fromologist. He had collected 50,000 cheese labels and wrappers, the country's most comprehensive collection. His specimens came from thirty-two different countries as far off as Japan, the USA, Mexico and New Zealand. When he started nineteen years previous there were only around a dozen fromologists in England.

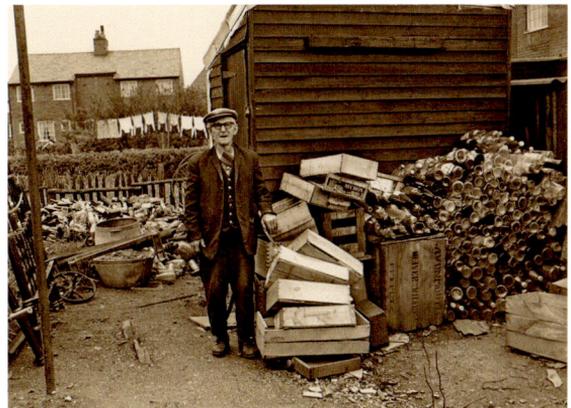

Sports and Barnsley FC

Gillian Hewby is shown at the Drighlington Dog Trials. Racing was viewed from a fully licensed lounge bar serving Barnsley Bitter on draught. The 1966 Earl Haigh Handicap Sweepstake was for the British Legion Trophy and £40 prize money. Friday night races were over 400 and 500 yards, although Two Grand Holiday Race meetings for the 1966 August Bank Holiday included races over 650 yards. The Greyhound Stadium on Highstone Road, Worsborough Common, closed in 1990 after a fire and is now a housing estate.

A racing car simulator, a brown bear and Monica the elephant all appeared at the Magnet Bowl. It opened in 1964 but by December 1968 it became the second Barnsley bowling alley to close. Broadway Bowl had only lasted a year but its owner had tried unsuccessfully to get visits to the bowling alley designated a school sport. Magnet Bowl had thirty-two lanes with a private licensed bar and hosted various leagues that faced an uncertain future. In 1970 a planning application for a supermarket in the Magnet Bowl was turned down.

In 1970 Barnsley's Tom Atkinson won the British One-Armed Golfers Championship having lost his left arm in a mining accident. He beat the previous champion David Lawrie in Prestatyn. Soon after for the first time the British Open Golf Championship at St Andrews sold a commemorative tie. It was designed by Bob Midwood, a former tournament golfer who had a shop on Shambles Street. In 1967 he had also designed a tie for the Cup Final. The shop closed in 1997, Midwood blaming Meadowhall and parking restrictions.

Barnsley welterweight Shaun Doyle lost valiantly against the British champion Jimmy Cooke on 9 May 1967. He had signed for the 'Aldgate Tiger' Al Phillips who arranged the fight. It had been fifty years since a Barnsley-born boxer, featherweight Charlie Hardcastle, had such an important fight. Shaun Doyle, a local scrap metal merchant, was now able to become a landlord at the Plough Inn. Doyle claimed he suffered worse injuries playing for Barnsley Rugby Union Club than during his boxing career.

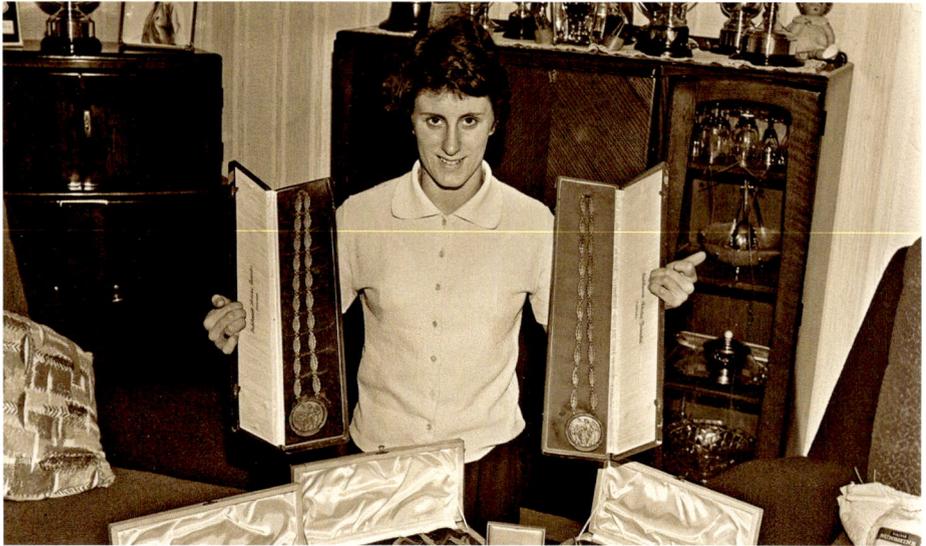

At the 1958 Commonwealth Games in Cardiff seventeen-year-old Dorothy Hyman was part of the gold-winning relay team and in Stockholm the European Athletics Championships silver medal relay team. At the 1960 Rome Olympics Hyman won silver in the 100 metres and bronze in the 200 metres. She won the sprint double in Perth at the 1962 Commonwealth Games and another gold in the 100 metres at the European Championships in Belgrade. Hyman also won silver and bronze with the 200 metres and the 4 × 100 metres relay teams. She was not fully fit at the Tokyo Olympics but still won bronze in the 4 × 100 metres relay.

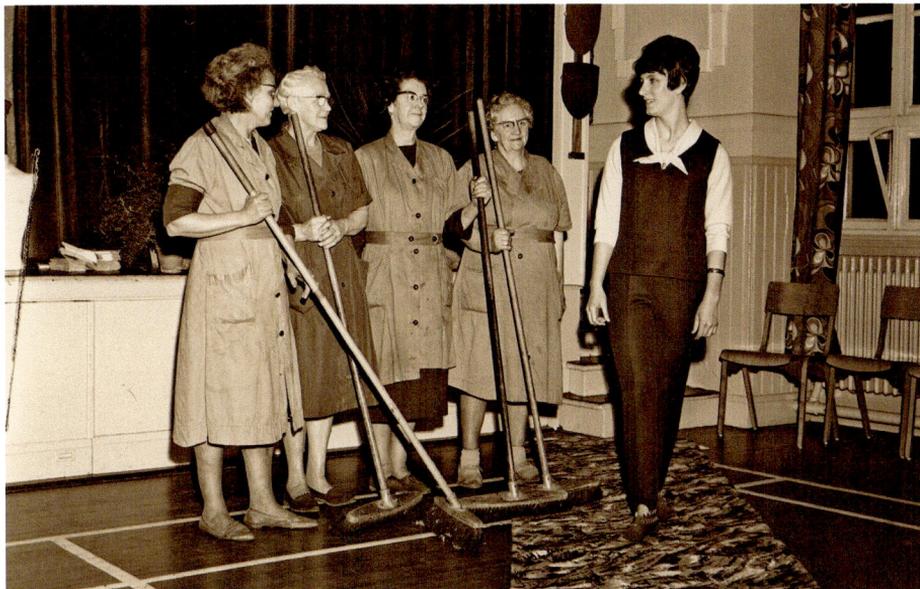

Dorothy Hyman was 1963 Sportswoman of the Year and awarded an MBE in 1964. Despite sweeping up so many medals Dorothy forfeited her amateur status when she was paid £150 to write a book, *Sprint to Fame*, and had her life story serialised in a Sunday paper. The last British woman to get an individual Olympic medal at 100 or 200 metres could no longer compete in international events. Residents in Cudworth sent a petition to Minister of Sport Dennis Howell to get her reinstated. The petition was placed in pubs, shops and clubs in Cudworth, Shafton, Brierley and Grimethorpe.

Dorothy Hyman turned to coaching at her eponymous track club in Cudworth. She trained three England sprinters: Sheila Cooper; Denise Ramsden; and Valerie Peat, a twenty-one-year-old seamstress from Thurnscoe who was then officially Britain's fastest woman. After competing against Germany at White City, Valerie was picked to go to Mexico for the 1968 Olympics. Peat had run the 100 metres in 11.4 seconds and the 200 metres in 23.6 seconds. However, Dorothy Hyman's times of 11.3 seconds 23.2 seconds were still better.

Dorothy Hyman had her request to be reinstated as an amateur granted by the Women's AAA Executive Committee. Dorothy, then twenty-seven years old, was working for the NCB at Woolley Colliery and was to make her comeback in an athletics event in Hull on 25 May 1968. The former Olympic Games medallist, who was still banned internationally, said she was now running purely for enjoyment.

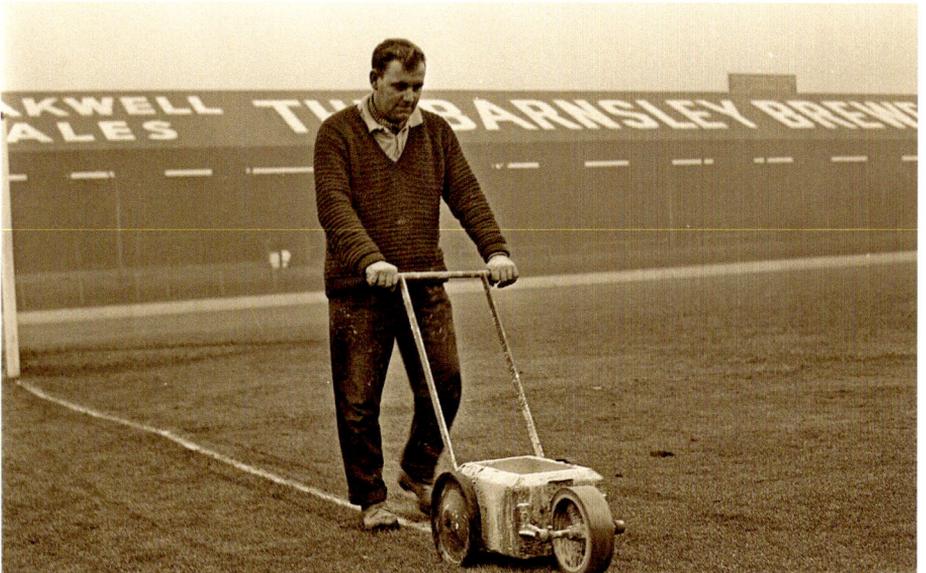

A number of Barnsley-born players went on to great things elsewhere. Darfield-born Gordon West played for the church team and went to the Foulstone Secondary Modern. After starting out as a groundsman at Blackpool he played alongside Stanley Matthews. He was transferred to Everton for a record fee for a goalkeeper and won the First Division twice and the FA Cup. The *Chronicle* celebrated his first game for England in 1968 against Bulgaria and his wedding to concert pianist Dorothy Ann Pickup.

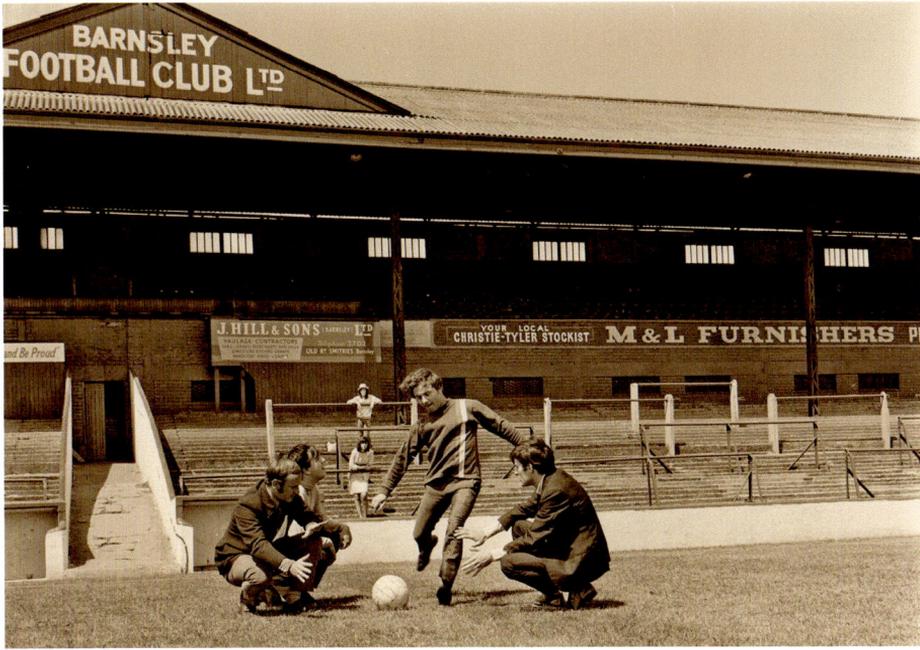

Gerry and the Pacemakers were at Oakwell in June 1967 when Brian Greenhoff was still a pupil at Racecommon Road School and his older brother Jimmy was at Leeds United. Manchester United signed the England youth player from Barnsley in 1968. Jimmy Greenhoff never played for England but he inadvertently redirected a sliced shot to score the winning goal for Manchester United in the 1977 FA Cup final, when Tommy Docherty was the manager.

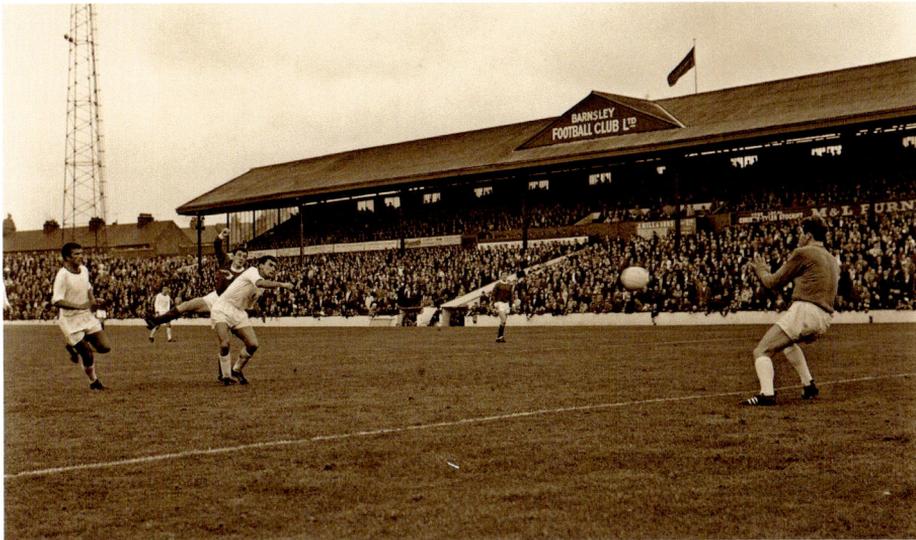

The 1967–68 season was massive for Barnsley. When two points were awarded for a win, they were one point from achieving promotion to the third division. Barnsley had just beaten Port Vale 2-0 with skipper Eric Winstanley scoring his fifth goal of the season and Jimmy Robson scoring a second. The game was played in front of 15,677 supporters. Promotion was clinched with a 1-1 draw away at Chester and it was skipper Eric Winstanley who scored to clinch promotion.

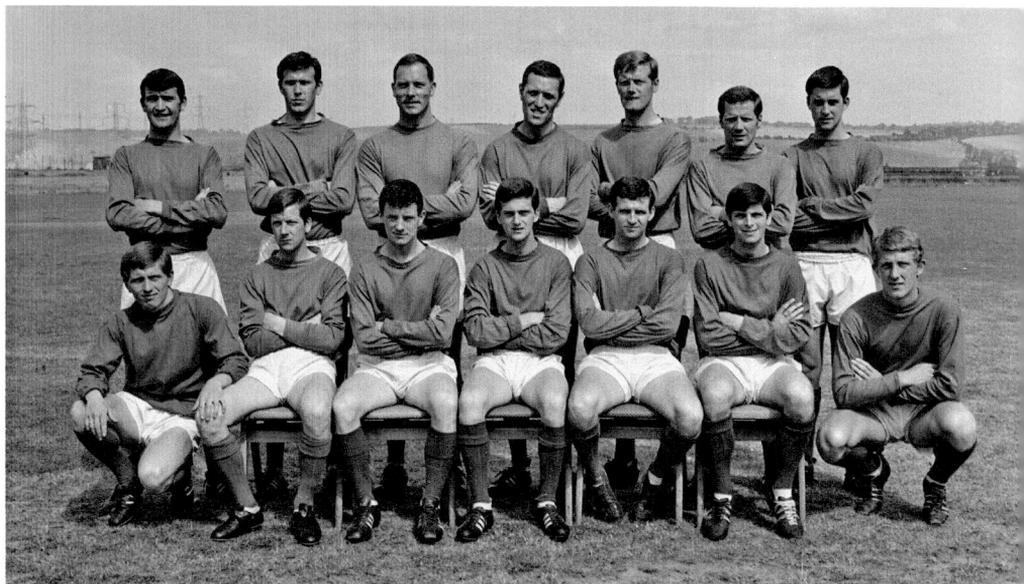

Barnsley chairman Ernest Dennis said at the Keresforth Hall Hotel that out of all South Yorkshire clubs Barnsley had the greatest potential because of the club's support and their stadium, Oakwell. Sadly a few days later, eighty-year-old Sir Joseph Richards died at his Keresforth Hall Road home after being taken ill at the FA Cup final. The former Barnsley chairman was former president of the Football League. Known as 'Mr Football', he was knighted in November 1966.

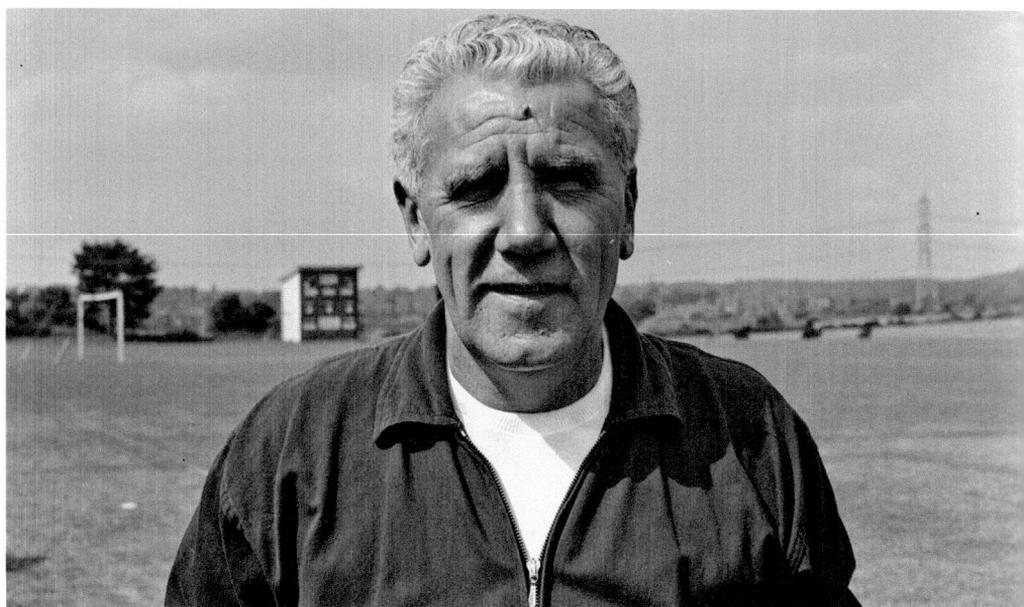

Johnny Steele, the Barnsley FC manager, spent £20,000 on two new players from Cardiff City. Cardiff's Frank Sharp and Les Lea signed for Barnsley in August 1970 to link up with former Cardiff City player Norman Dean. Glaswegian Steele had a thirty-year association with Barnsley FC having signed as a player in 1938 and was in the 1938–39 team that won promotion to the second division. When he became manager in the 1960s Steele declared his aim was to get Barnsley back into the second division.

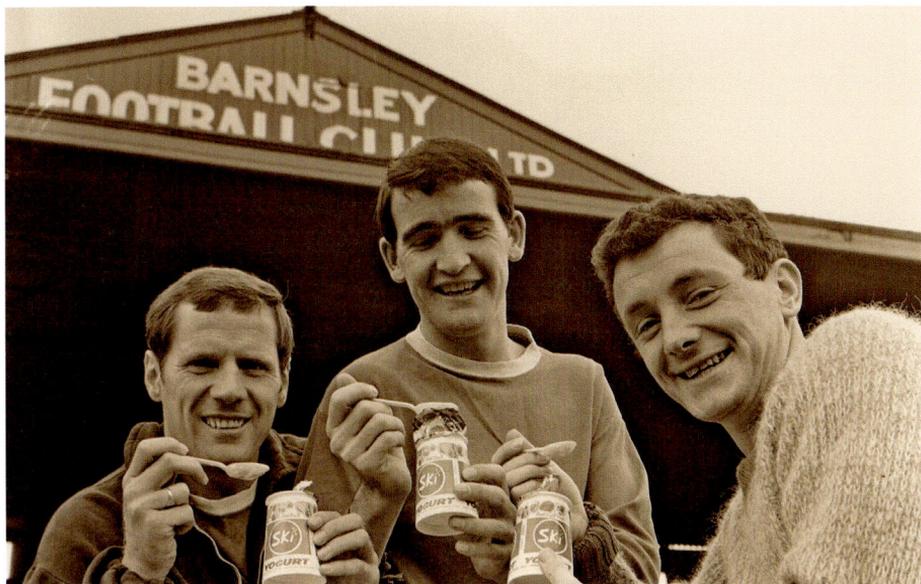

The headline in the paper was Barnsley FC players eating yoghurt. This was in 1967 when replica shirts were a novelty but was a portent of multimillion-pound competition, ground, shirt and sleeve sponsorship becoming the norm. Genghis Kahn reputedly fed his warriors yogurt, but before 1963 the UK yoghurt market was limited to health food shops. Then Swiss-invented Ski was launched in the UK and Barnsley FC helped it become ubiquitous.

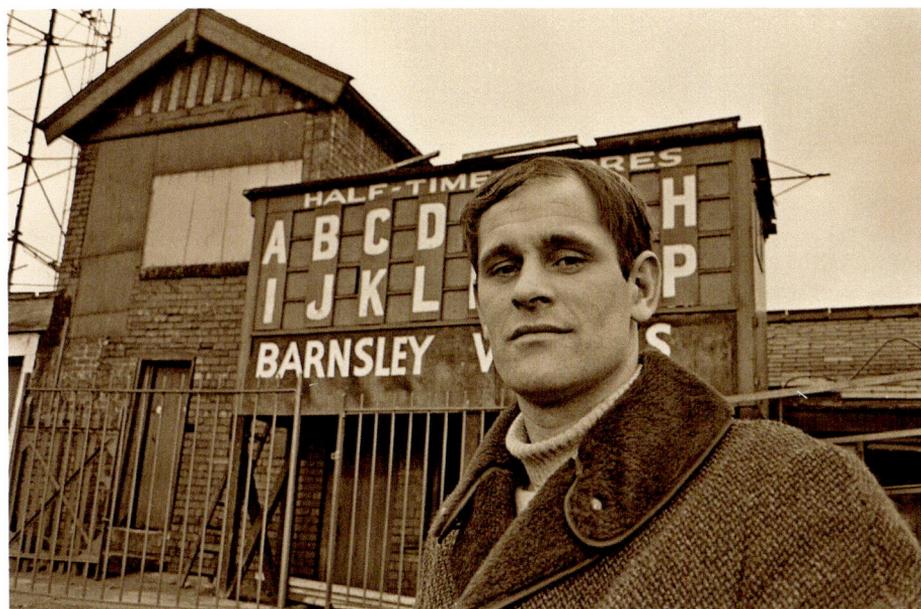

Jimmy Robson is pictured at Oakwell in January 1968. He had just signed from Blackpool and was in the Barnsley side that gained promotion from the fourth division later that year. The inside forward scored seventeen goals in ninety-eight appearances before leaving for Bury. Before Oakwell he was a first division title winner with Burnley and scored in an FA Cup final against Spurs. After retiring from playing in 1973 he enjoyed a successful coaching career.

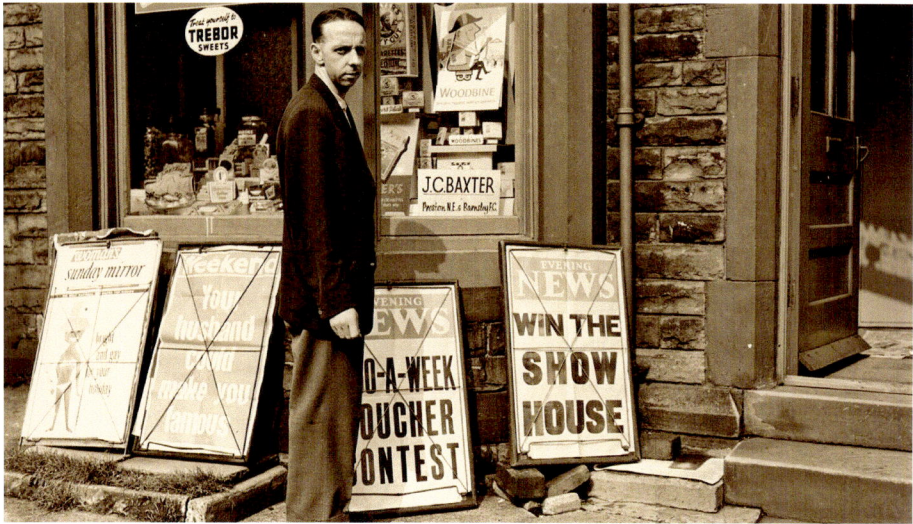

In June 1966 a Sports Exhibition at the Civic Hall was opened by Lynn Davies, 1964 Olympic long jump champion. It included trophies won by 1954 FA Cup finalist Jimmy Baxter when at Preston North End. He scored fifty-four goals for Barnsley, having signed in 1945 and came back to Barnsley in 1959. Other trophy winners included Danny Blanchflower, who started at Barnsley in 1949, and Eddie McMorran, who scored thirty-four goals in 109 appearances. Munich air disaster victim Tommy Taylor scored twenty-eight goals in forty-six games. At Manchester United he made nineteen England appearances, scoring sixteen goals.

Inside forward Eddie Fleetwood joined his hometown club in 1932 but only played fourteen games, scoring eight goals. Another player who had a brief association with Barnsley was Arnie Sidebottom who had captained the under eleven football team. Living on Clarendon Street, he was signed by Man United aged sixteen. He actually preferred cricket to football. Arnie's son Ryan would go on to play for England many times but Arnie only managed one Test match against Australia at Trent Bridge before he was banned for touring South Africa.

Two matches against eventual FA Cup finalists Leicester City were a star-crossed experience. Barnsley coach Norman Rimmington appealed to no avail, when 1974 World Cup final referee Jack Taylor inextricably ignored a foul by Andy Lockhead on Barry Murphy and a linesman's offside flag. The controversial goal meant Barnsley lost a replay 2-1 at Filbert Street. The loss followed a 1-1 draw at Oakwell which Barnsley could easily have won. Peter Shilton was forced to make some great saves for the outplayed First Division side.

Besides young footballers Oakwell helped nineteen-year-old Alan Hydes. In February 1969 Hydes competed for England in the World Table Tennis Championships. Alan trained at Oakwell five times a week. Alan was a surprise selection but starred in England's 5-4 win in the semi-finals over Hungary in Munich. Hydes was suffering from tonsillitis but claimed his training with Barnsley FC got him through. At the annual Table Tennis Club dinner, the president said when people were too ready to run Barnsley down the publicity Alan received was good for the town.

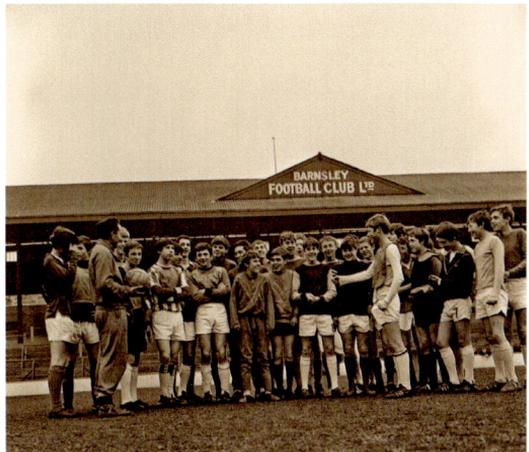

This shows a school sports day held at Shaw Lane. In June 1970 to stop pupils coming in half asleep, Mr P. E. Jones, the Head Teacher at Raley Secondary Modern School, appealed to his pupils to catch up on the Mexico world cup at lunchtime on the school TV. The school's most famous pupil, Harold Bird, began his umpiring career in a county game in the same year after playing for Leicestershire and coaching in South Africa. It was whilst at the school he got his nickname 'Dickie'.

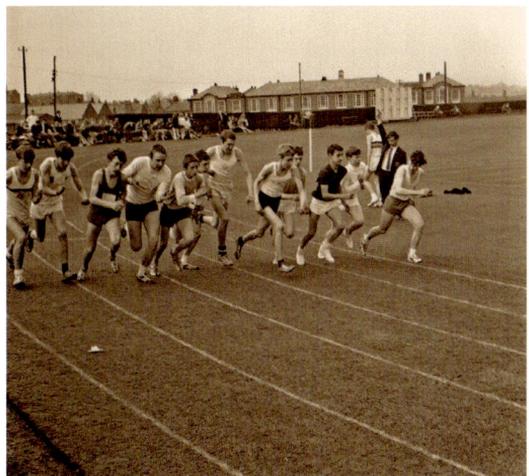

Industry and Coal Mining

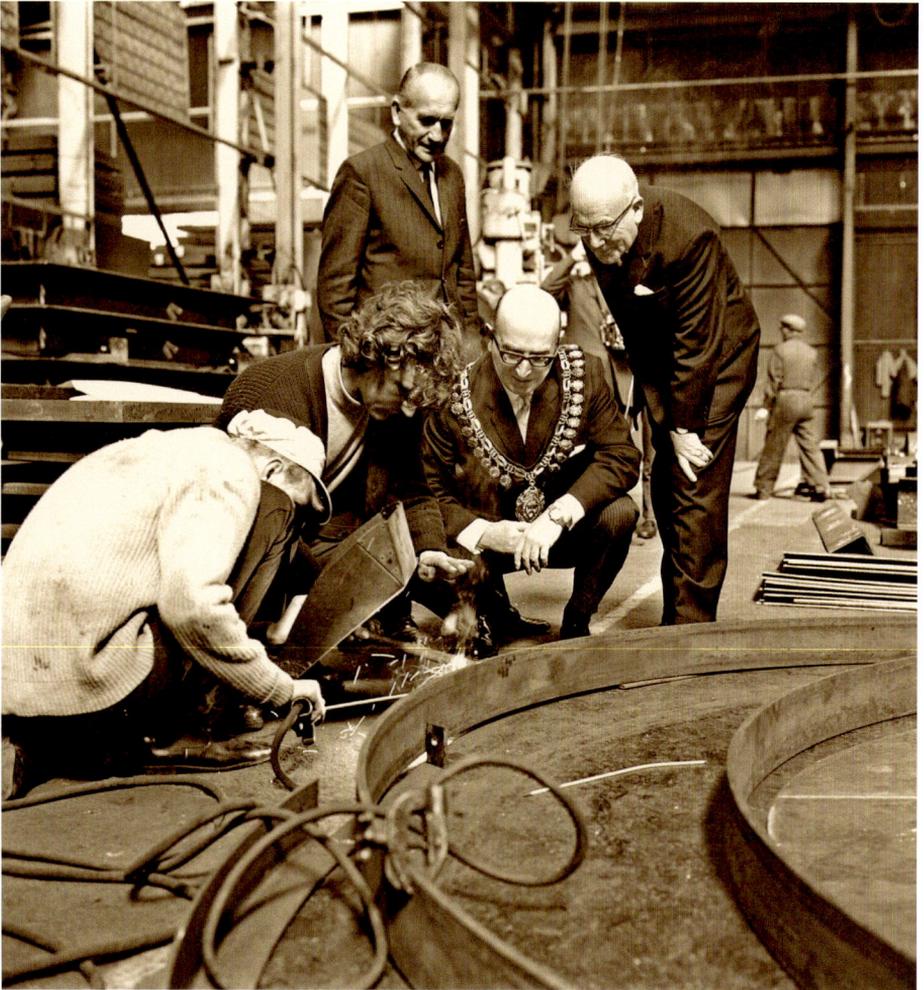

Qualter Hall Needham and Bower moved to Barnsley in 1868. Between the wars the works made engines and chassis frames for the Austin Motor Company. In 1970 Mayor Frank Crow visited the works to see the company's new diesel- and battery-powered shuffle car for use in South African mines. However, the order was put at jeopardy after the theft of bronze worm wheels from the stores. These took six months to obtain and they only had three weeks left to meet the order.

The Arcade entrance columns were made at Qualter Hall. The works on Summer Lane were originally known as Farrar's Foundry. During the First World War the works concentrated on producing shells and bullets. In the Second World War the factory produced parts for tanks and landing craft. A £1 million takeover by British Steel Construction took place because the five Hall brothers were retired or nearing retirement. Manufacture of equipment for a big export order soon took place overseas, apparently to avoid a seaman's strike.

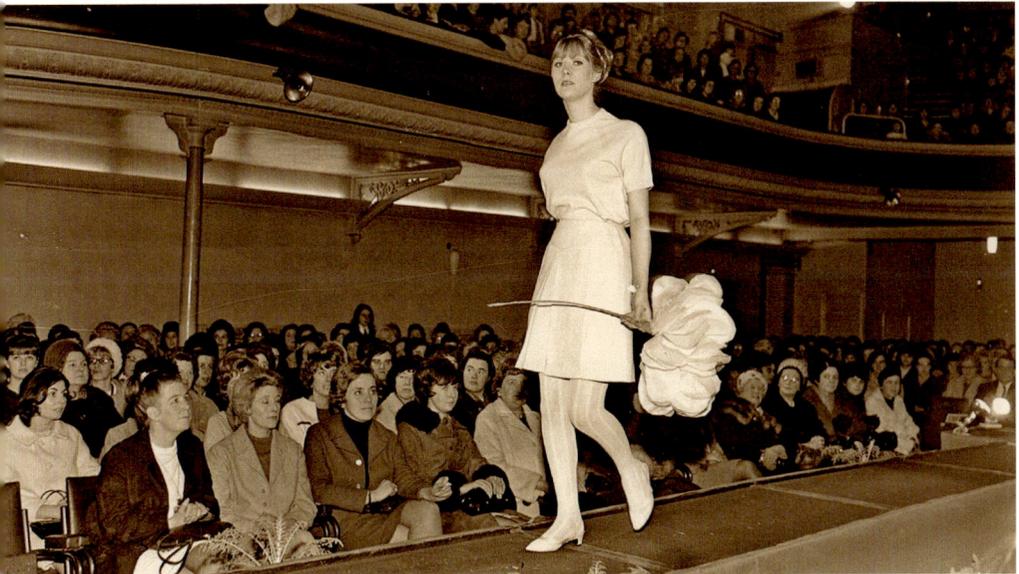

The Round Table modelling show was at the Civic Hall in 1968. Another fashion parade at the Civic Hall in October 1970 was for N Corah (St Margaret) Ltd of Worsborough Bridge. Samples of the company's work were modelled by employees, plus three children. The Leicester company opened a Barnsley factory in 1962 with nineteen staff; by 1970 there were 850 employees. In 1969 a number of factories claimed there was a female labour shortage due to the rapid expansion of clothing businesses needing more and more machinists.

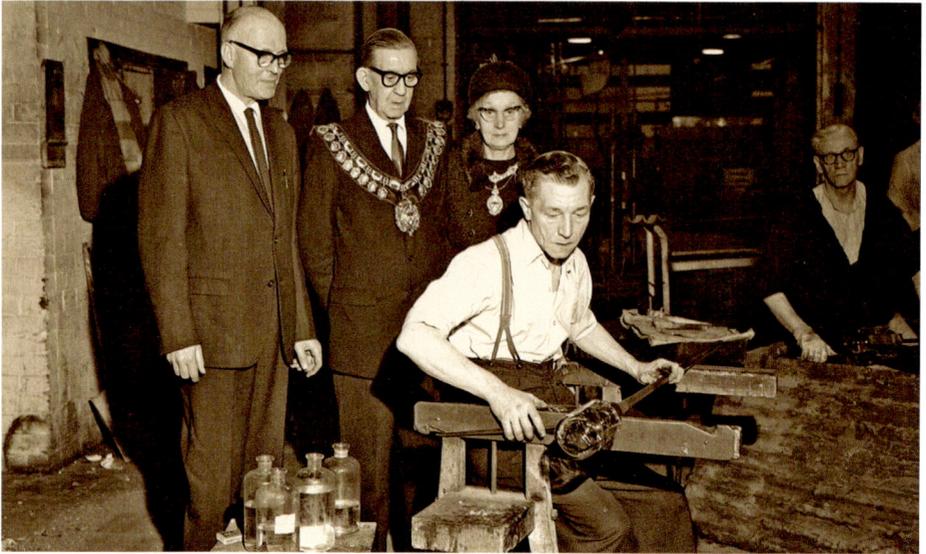

Traditional glass blowing is demonstrated at Redfearn National Glass, which in 1968 started producing Canada Dry bottles. Bottles with RBB on the base were made in 1862 adjacent to Barnsley Canal. A new plant at Monk Bretton opened in 1946 and the Old Mill Lane works closed in 1967. Redfearn's produced 160 tons of glass a day in 1970 but a joke prompted the works manager to demand a 'gag' order be placed on comedian Wyn Calvin who compared *Babes in the Wood* 'panto robbers' punishment to be a night shift at the works.

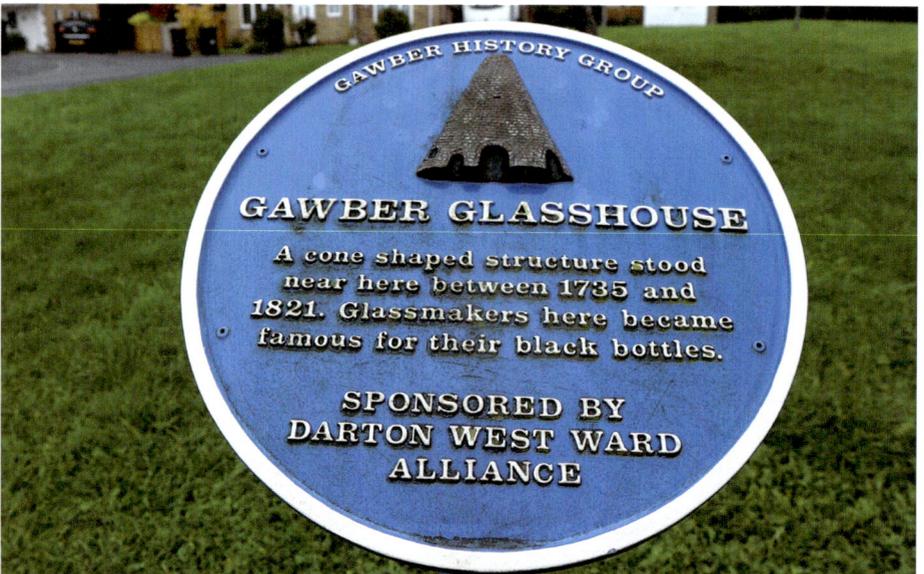

GAWBER HISTORY GROUP

GAWBER GLASSHOUSE

A cone shaped structure stood near here between 1735 and 1821. Glassmakers here became famous for their black bottles.

SPONSORED BY DARTON WEST WARD ALLIANCE

The legend of Gawber Black Glass was authenticated when the Barnsley Archaeology Society discovered the site of the Gawber Glasshouse in a cornfield. The glassworks, founded by William Thorpe early in the eighteenth century, produced glass so dark that no light could penetrate it. Special wine bottles containing the family crest were exported and examples turned up in Virginia. Hundreds of glass fragments from the furnace were reassembled to create a bottle which was sent to Cannon Hall in 1966.

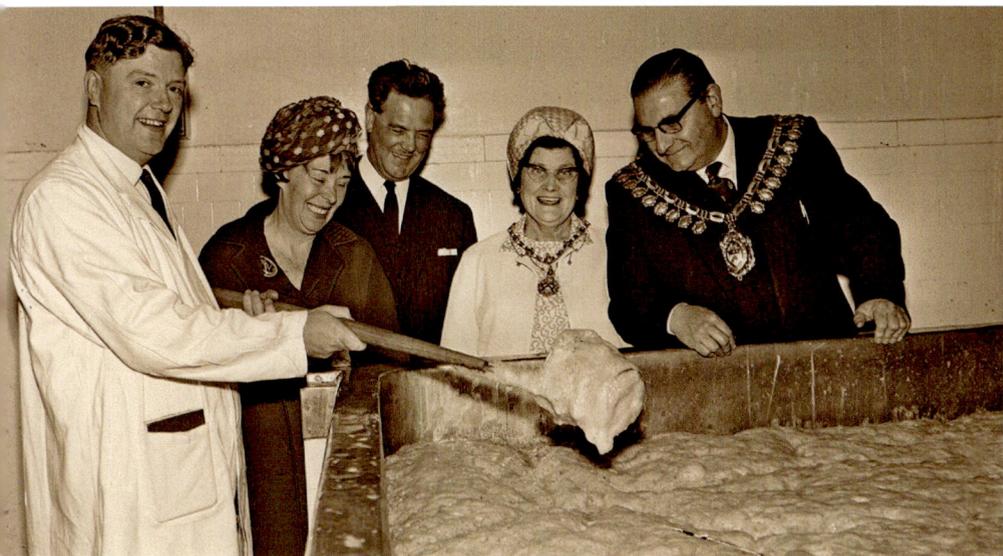

A mayoral visit to Barnsley Oakwell Brewery in 1967 coincided with a reshuffle to the Board. Acquired by John Smith's in 1961, the link with the Tadcaster brewery was reinforced when William Edward Harbord became chairman. Ted Umbers MBE who, amongst other things, captained Barnsley Cricket Club in the early 1930s and was on the Yorkshire County Cricket Club Board, became president. The Oakwell Brewery was founded by Guy Senior but the Oakwell site was cleared in 2013 after more than 120 years.

The 1968 Christmas panto cast visited Star Paper Mill, which in August had installed a new £1.25 million off machine coater, the first of its kind in the UK. The investment was to consolidate Star Paper Mills' position as one of the leading manufacturers of high-quality coated papers in the UK. However, Star's profits were down for 1969 and by April 1970 it was necessary to make redundancies. The new machine coincided with a depressed paper trade and increased foreign competition.

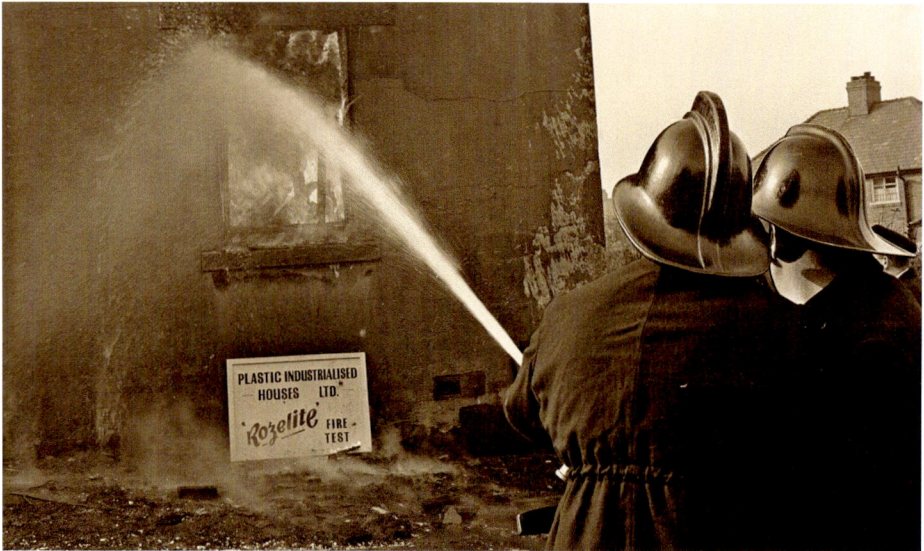

In March 1970 the Minister for Technology, Eric Varley, visited Barnsley to promote the government factory building programme and the Local Employment Act. This provided grants for industrialists and local authorities. Plastic Industrial Houses Ltd based at Stairfoot was a new industry already producing flower boxes for Harrods and seagull-proof litter bins for Bridlington. They were exporting goods to Norway, Sweden and Jamaica and this 'Rozelite' fire test was carried out for the company in 1967.

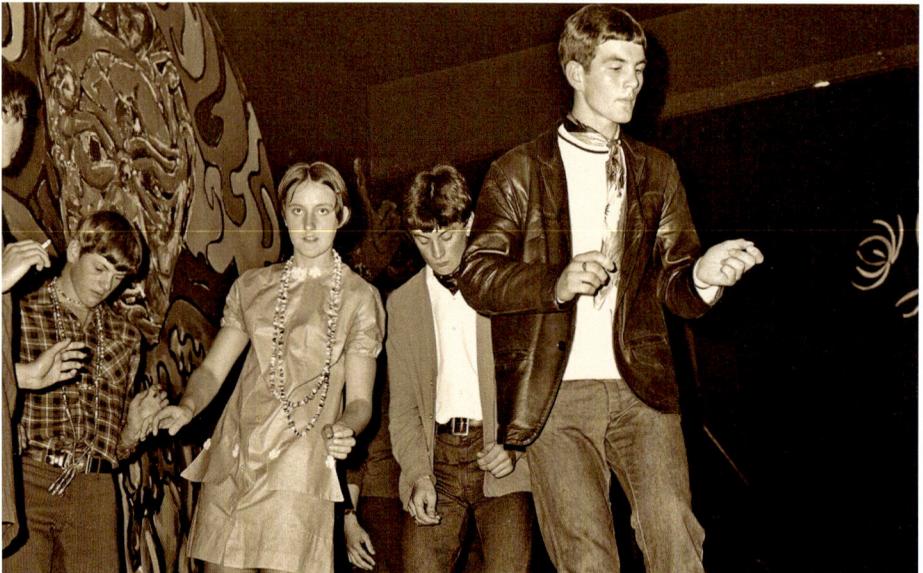

As fashions were shifting the Denby Dale Shirt Company, now manufacturing abroad, formed in Mapplewell in October 1965. By 1968 it had doubled its production and had a stand at the International Men's and Boy's Wear Exhibition at Earls Court. They produced in vogue polo neck and flowery shirts and in May 1968 American singer Soloman King visited their factory before appearing on *Top of the Pops* wearing one of the company's polo neck shirts. King's first stage name was Randy Leeds.

The iconic CEAG factory was demolished to accommodate the Glassworks development. With mining under pressure, innovation was needed in long-established firms centred on Barnsley's traditional industries. CEAG started by making mining safety lamps and the factory had giant concrete replica lamps on the roof, but in 1970 they created another revolution with Gemini. They formed the Yorkshire Dryer Company, sole manufacturer of what was the first twin dryer on the market, which would double launderettes' drying capacities.

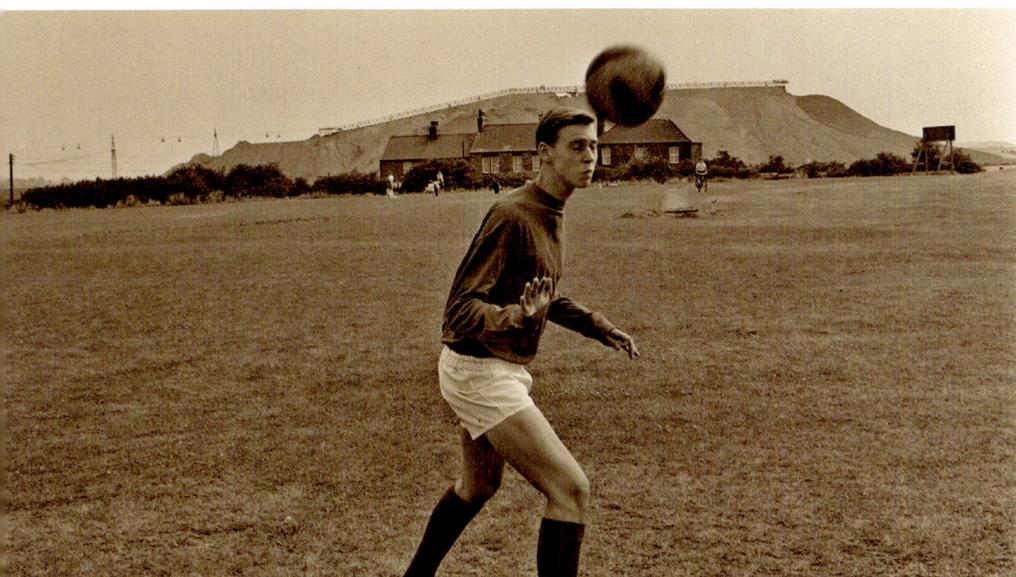

This giant 'Muck Stack' was the backdrop for Barnsley FC training. On April Fool's Day in 1967 it was reported that local painter Glyn Amos had an exhibition of pit stacks using gravel and sand at Cannon Hall. The Hunt Report was meant to address the issue and in March 1969 Home Secretary James Callaghan promised action at the Miners Hall. When first elected in 1956 Roy Mason had campaigned to clean up the pit heaps and was now in charge of getting the Mines, Quarries and Tip Bill though Parliament.

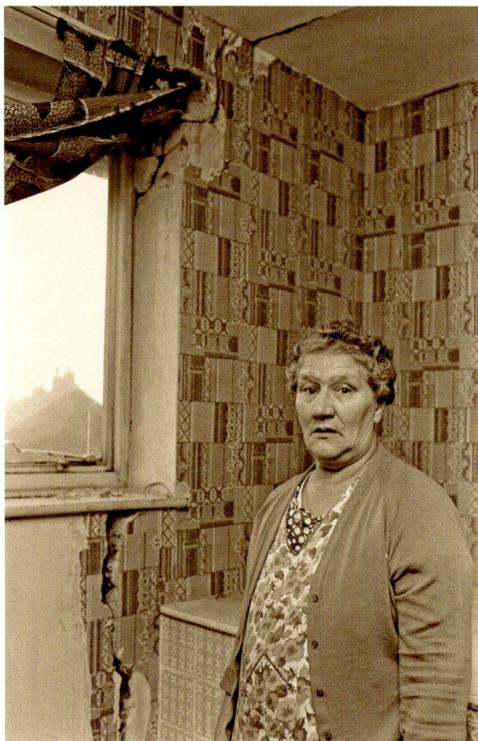

In April 1970 houses were evacuated on the Elm House estate in Worsborough where residents were living in fear of collapsing houses – cracks were appearing in walls and ceilings. Subsidence caused gas and water mains to burst and affected electricity cables. Even the M1 extension was hampered by mining subsidence. Bridges and other structures had to be designed to take account of the potential 10 feet 6 inches of movement. To find shallow mines and bell pit shafts exploratory boreholes were dug extracting 50,000 tons of coal in the process.

Dorothy Hyman is pictured with Lord Robens, the Coal Board chief. Robens was invited by a Mr Strutt to visit his subsidence-hit street near Barrow Colliery. His bedroom wall had a huge crack and he could see into the neighbour's bedroom. The residents had no hope of selling their houses. One elderly resident was too scared to sleep at night; another had boarded up their back door for fear of being hit by falling bricks. The NCB said repairs could not be done until subsidence had settled.

Woolley Edge Colliery had an accident-free year in 1962 and the National Association of Colliery Overmen, Deputies and Shotfirers presented an award at the Arcadian to celebrate. May 1968 saw the opening of the NACODS' new headquarters. Built at a cost of £50,000, the brutalist architecture divided opinion. Abutting the old Grammar School, the boxy windows facing Church Street which lit the conference hall and committee rooms were unconventional. The building perished on the pretext of a yet-unbuilt office.

In August 1966 the NUM awarded a one-off £70 nest egg to retiring miners (around £650 today). This replaced the 4s a week they previously received. In February 1969 they gave ninety retired or disabled miners free holidays at Easington Beach Holiday Park. The invitations were presented by actor Pat Phoenix. In the same month there was a poor response to an NCB recruitment drive aimed at ex-miners. Most of the ex-miners were in their sixties, but the outstanding vacancies were for physically demanding face work.

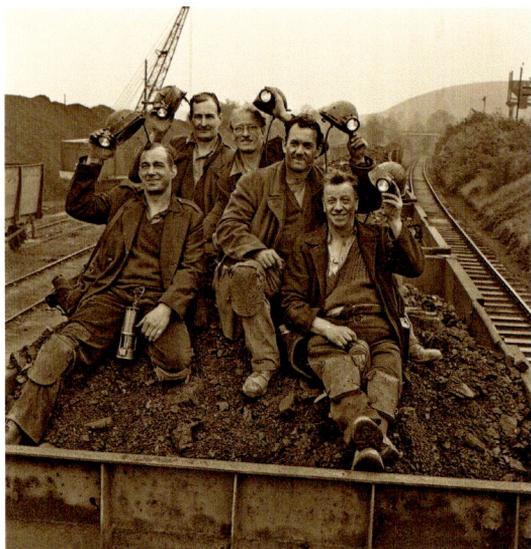

There were twenty-five pits within Barnsley at the turn of the century when most coal was produced using hand tools. Barnsley's pits generally had thinner seams unsuitable for modern mining methods and as mechanisation gathered pace the town suffered a greater number of closures. In August 1970 Lord Robens opened Riddings Drift Mine near Wakefield, which did not help Barnsley's position. Using American equipment, it produced far greater amounts of coal per man in an attempt to compete against oil, natural gas and nuclear.

To promote the industry the NCB published an advert in March 1969. It was a cartoon with a young man telling all his friends what a great job mining was. The message was the money's good and I'm never bored. What more do you want? This 'photo op' was provided by *Mother Goose* star and former Miss World Ann Sydney. Brass bands served a similar purpose and the Monk Bretton Colliery even had its own Symphony Orchestra that played to packed audiences in St Paul's Church.

In June 1966 plans to convert former NCB headquarters, the seventeenth-century Worsborough Hall, into a country club fell through. Whilst an alcohol licence had been granted for a hotel, new owner and trained stonemason Alan Wyatt decided to reinstate residential use. Although, much of the Grade II listed building had been constructed around 1620, a fireplace pre-dated the Dissolution of the Monasteries (1536–41). The historic mansion also held a cabinet containing accessories and papers of ill-fated King Charles I, executed in 1649.

Miners Demonstration and Centenary

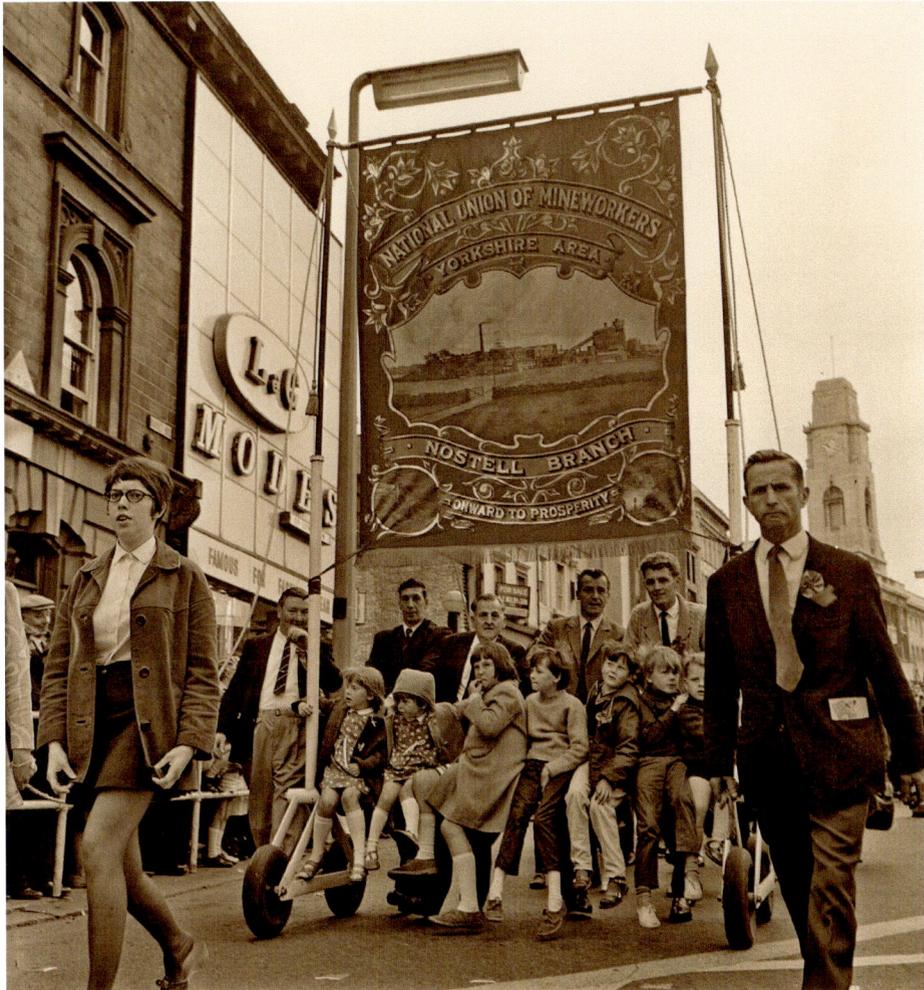

The Miners Demonstration and Gala was held in Barnsley in June 1969. It started at Churchfields and after passing the Miners Hall ended at Locke Park. After a welcome by Mayor Ald. Theodore Hinchcliffe, Roy Mason spoke as Minister for Power. Other events included a fashion parade, tug o' war, Coal Queen competition (won by Jennifer Zincke), a funfair and Punch and Judy show. The gala included a show of ponies from the Retired Pit Ponies Rest Home. Recently retired George Turner had cared for 111 ponies at Manor Farm near Wooley Colliery.

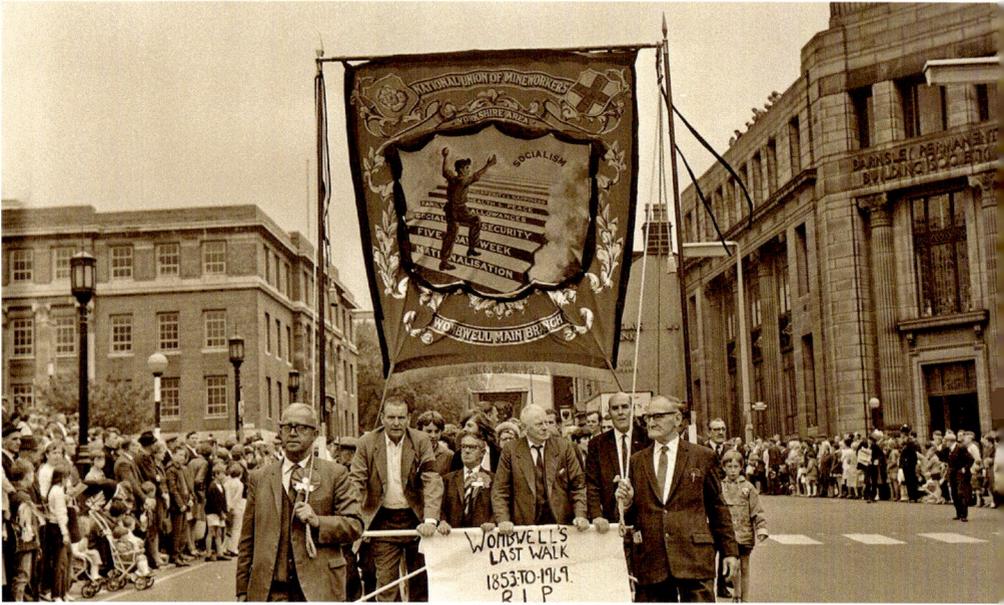

The procession was led by the West Riding County Fire Service Silver Band, Pipes and Corps of Drums. Colliery banners, many now on display at the Miners Hall, were the most prominent feature. One banner had a sign highlighting the closure of Wombwell Main Colliery. Some of these hefty banners were carried on poles whilst most were attached to wheeled metal frames – ideal for children to hitch a ride.

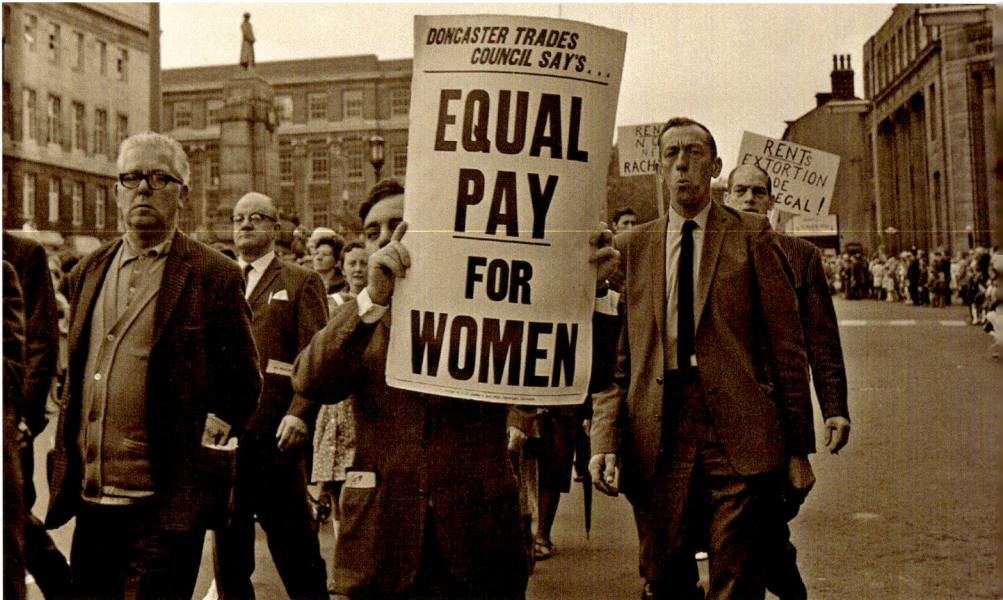

The parade did not just include NUM members; the mounted police and the fire service were among the many other organisations present. Historically smaller trade unions had ceased to exist when they merged with the NUM. The Yorkshire Winding Enginemen's Association lasted fifty-one years and had 350 members when it merged. Besides the elaborate colliery banners there were homemade banners opposing the NCB, who had a marquee at the gala. Other banners related to causes of the day.

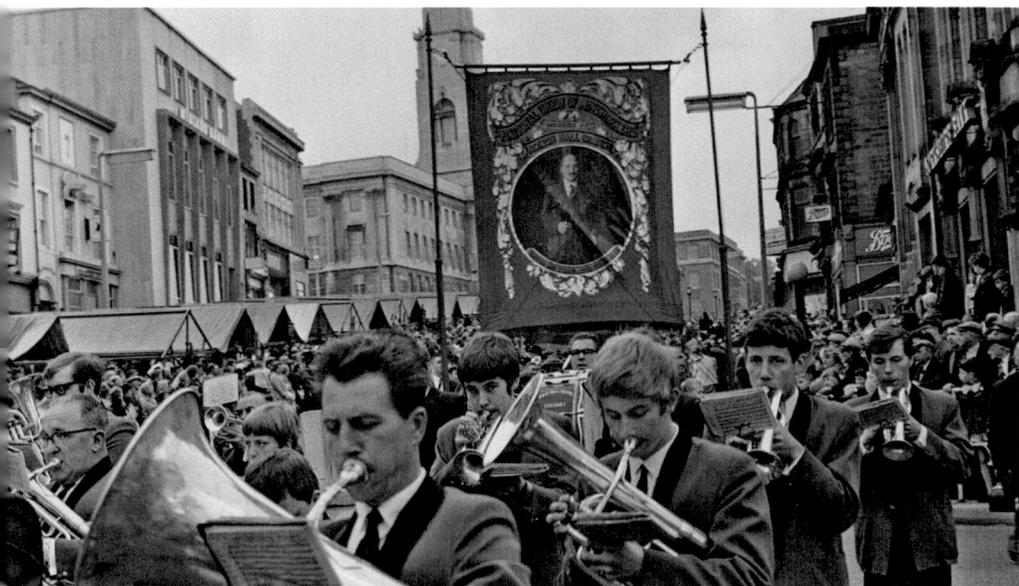

There were thirty marching bands including a tambourine or timbrel band, bagpipe bands, bugle bands and brass bands. The Houghton Main Colliery Band folded due to lack of members but was reformed under a new musical director, Win Moore. The reformed band changed the venue for rehearsals to the Clarence Hotel, former headquarters of Barnsley FC. They moved into the Barnsley area to tap into the pool of talented children who had been taught music in the local schools.

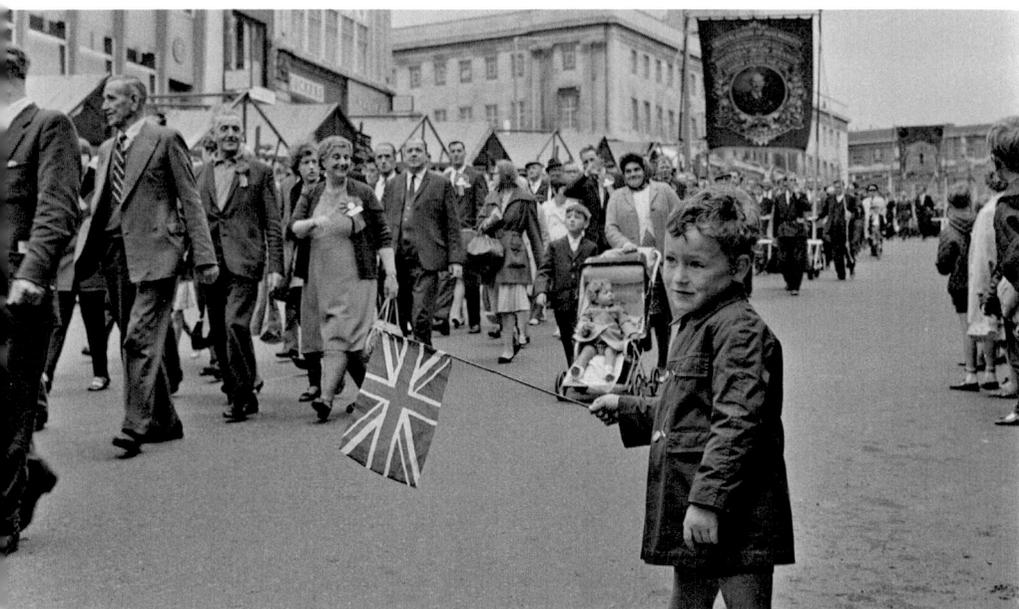

Business near the route did very well. The town's newest pub, the Silkstone, was only a short walk from Locke Park; it replaced the Providence and the Duke of Leeds. At the opening Tetley said the pub was a tribute to the mining industry. In June 1966 a train booked to take 500 delegates to the Miners Gala in Rotherham was in a shocking condition, forcing British Rail to apologise. The dirty train did have not enough coaches and had no toilets.

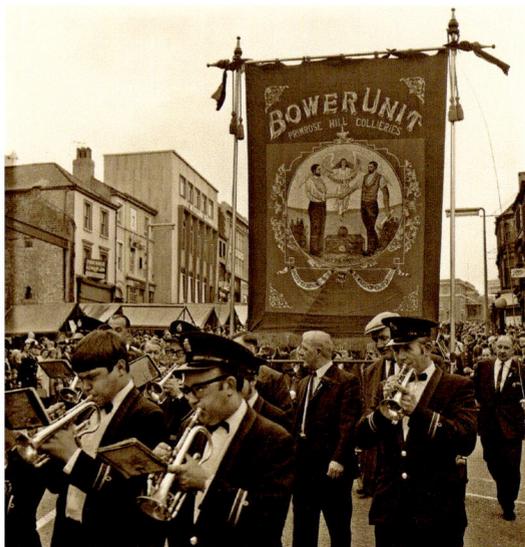

The 1962 Miners Gala was held in Dewsbury. It was reported there were 105 pits in Yorkshire and 15,000 miners attended. Labour leader Hugh Gaitskell, who was looking likely to replace Harold Macmillan as Prime Minister, wanted more council houses for those displaced by slum clearance. NUM chairman Sam Bullough wanted to place restrictions on increasing imports of oil as part of a national fuel policy and proclaimed national safety year a very worthwhile scheme.

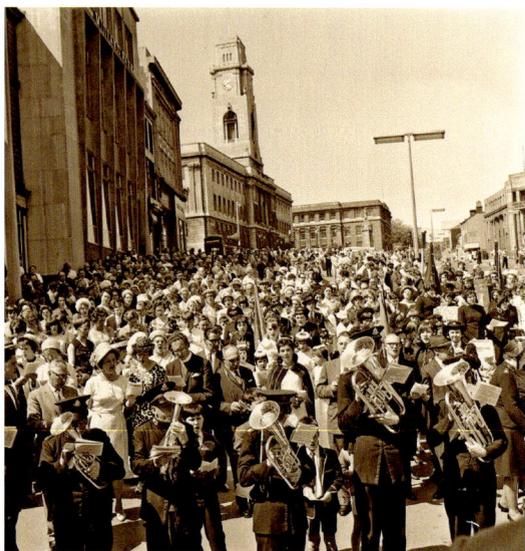

You wait long enough and two major celebrations arrive in quick succession. The town's borough status was granted by Royal Charter a hundred years earlier in July 1869. The main event for the Centenary was a freefall parachute display by the Black Knights Sky Divers of the Royal Horse Artillery at the Queens Ground. Serendipity struck when staff working in the attic of the Civic Hall found photographs of past mayors and a portrait painting of the very first Mayor Ald., Henry Richardson.

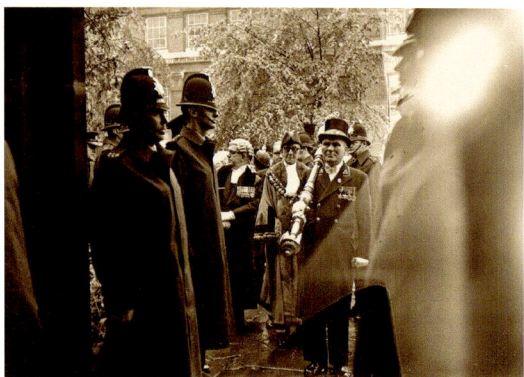

Amongst the civic functions is the annual Mayor's Parade. As part of Barnsley Centenary celebrations on 12 July 1969, the mayor led an especially grand parade, which started at the Cenotaph before a procession of thirty-six floats and ten brass bands toured the principal thoroughfares. After slowly making its way through the crowds a special service was held at St Mary's Church. After the service the celebrations concluded at the Town Hall where mayor Theodore Hinchcliffe took the salute.

Civic Life

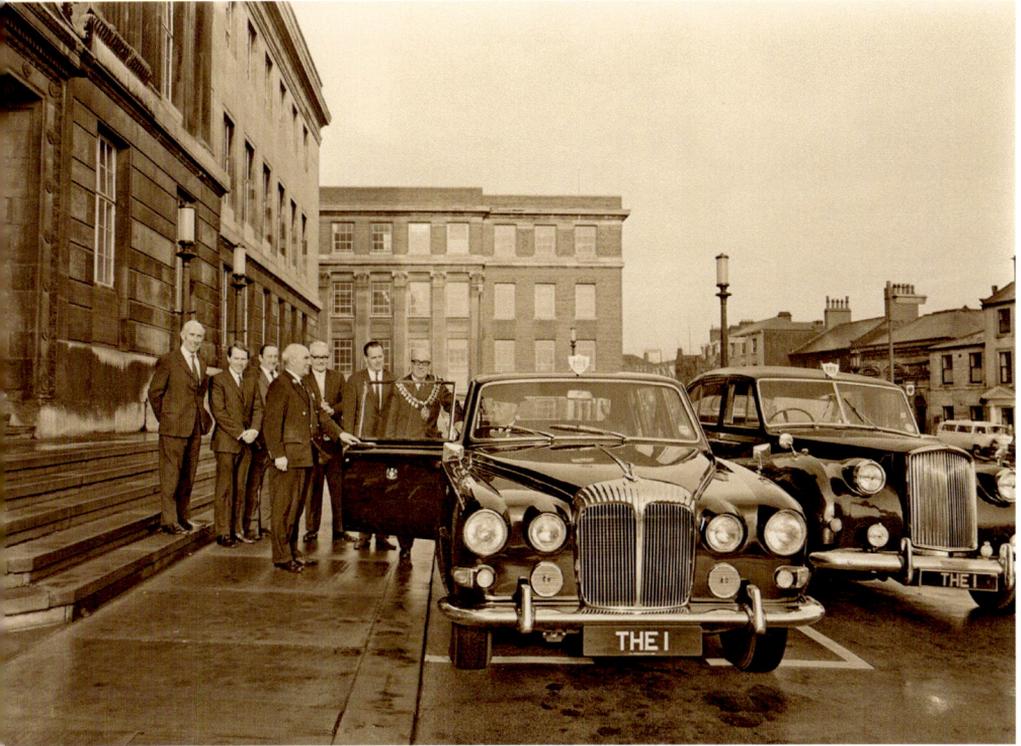

While other towns chose a Rolls-Royce, Barnsley's mayor chose a £4,994 Daimler Limousine with the registration THE 1. The new car was handed over at a ceremony at the Town Hall in November 1970. In attendance was the mayor's chauffeur, Mr A. Hunt. Frank Crow's Daimler was the Queen Mother's favourite car. It had walnut cabinet work, deep pile carpets, cigar lighters and ashtrays in the armrests. The interior coachwork was crafted by Vanden Plas. Only 450 of these luxury cars were built each year.

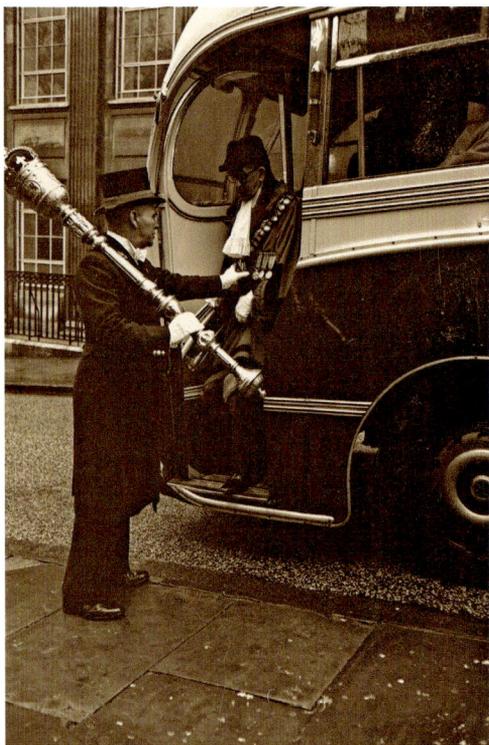

In August 1970 Charles Clifton, Barnsley Town Hall Superintendent and Macebearer, was installed at a ceremony in Scarborough, 'Grand Primo of the Guild of Macebearer'. This was a first for Barnsley. In his acceptance speech he said macebearers had to uphold the customs of old England with dignity. He also said that Barnsley Town Hall is one of the busiest in the north and has one of the longest and heaviest maces, which is now on display in a glass cabinet.

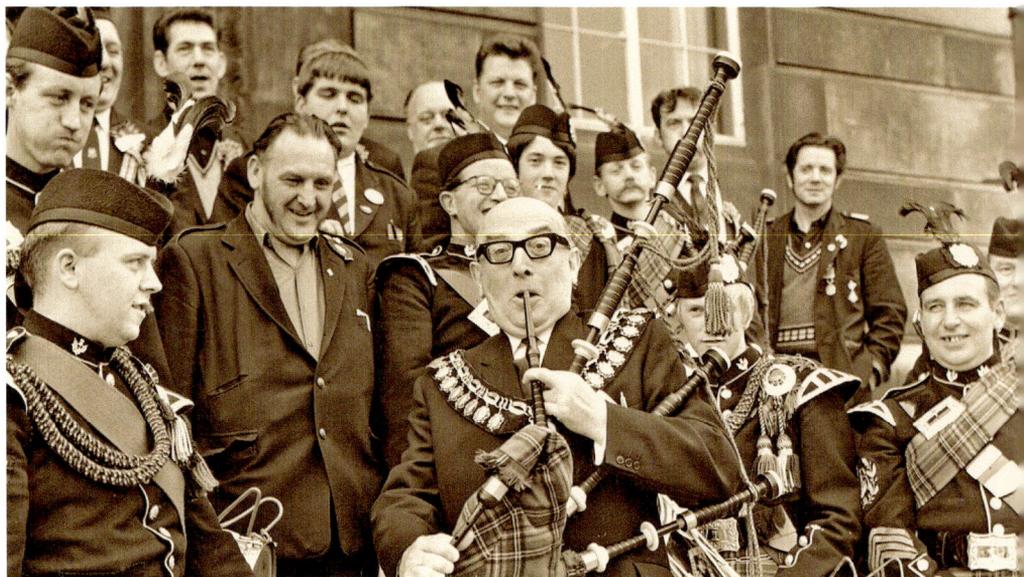

In November 1966 bus workers changed their annual conference venue to Barnsley Town Hall. This was because the Mayor of Barnsley, Alderman Williams Martin-Chambers, was a former bus driver. In October 1970 a Scottish Motor Traction Parade took part in the forty-first annual three-day visit to Barnsley. A fifty-person parade preceded a civic reception with Mayor Frank Crow. Amongst other things the visitors competed for the busman's international football match, the Erskine Trophy at the Barnsley British Cooperative Society sports ground.

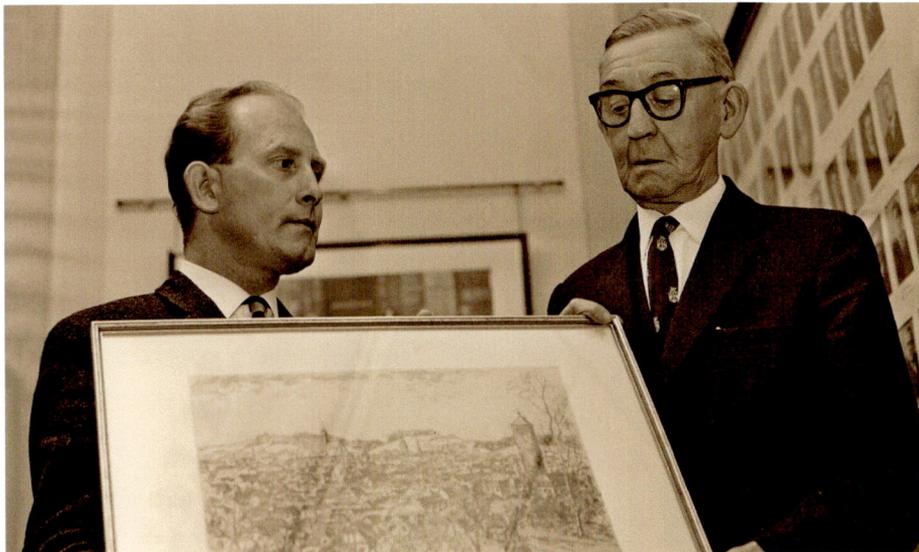

In September 1969 this presentation took place at Barnsley Town Hall as part of the Twin Town process. History was made in 1968 when Barnsley and Schwabisch Gmund were officially twinned. Mayor Ald. Albert Lowery shook hands with the Oberburgermeister Herr Hans Ludwig Scheffold on the steps of the Town Hall. However, there was a protest against the mayor and lady mayoress taking a trip to Schwabisch Gmund after cuts that had been made to the Centenary Celebrations budget.

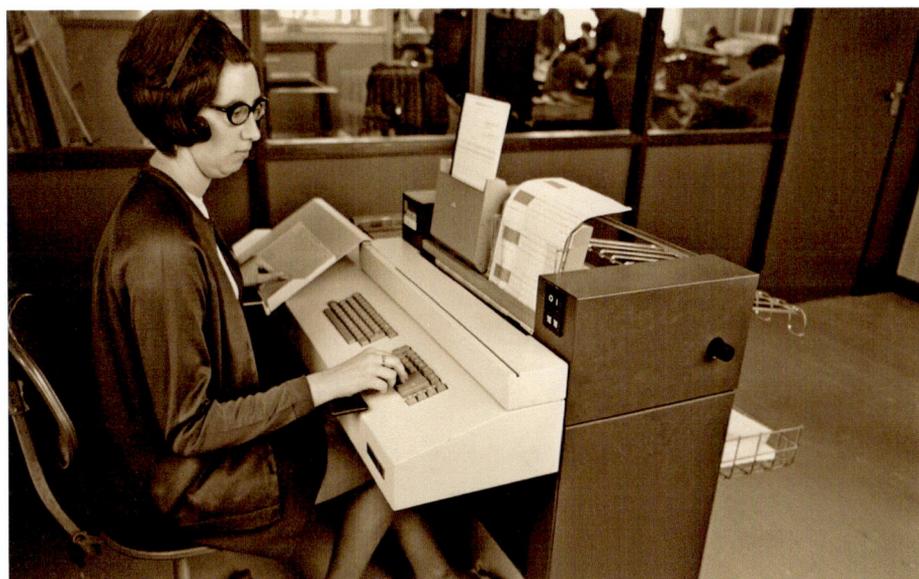

In August 1970 Yorkshire Traction showed off its new computer system. However, Barnsley Town Council had already set up a computer centre on Shambles Street in cooperation with three other councils in May 1967. Eight staff in the computer centre could do the work of 105 staff and calculate 5,000 wage packets an hour. This was all prompted by decimalisation, which had an unexpected benefit. The discontinued penny meant toilets on Kendray Street were free as the coin was no longer legal tender.

Guy Fawkes was a new Fire Service recruit in November 1970 a few weeks after a fire broke out next to the Civic Hall in G Burnett & Sons Ltd. Being a wallpaper and paint shop the fire spread quickly and gas pipes had already melted. The fire was discovered early by a policeman who smelled smoke, and firemen stayed all night fighting the blaze. The fire could have destroyed the hall and surrounding shops, according to Chief Fire Officer Fred Hall.

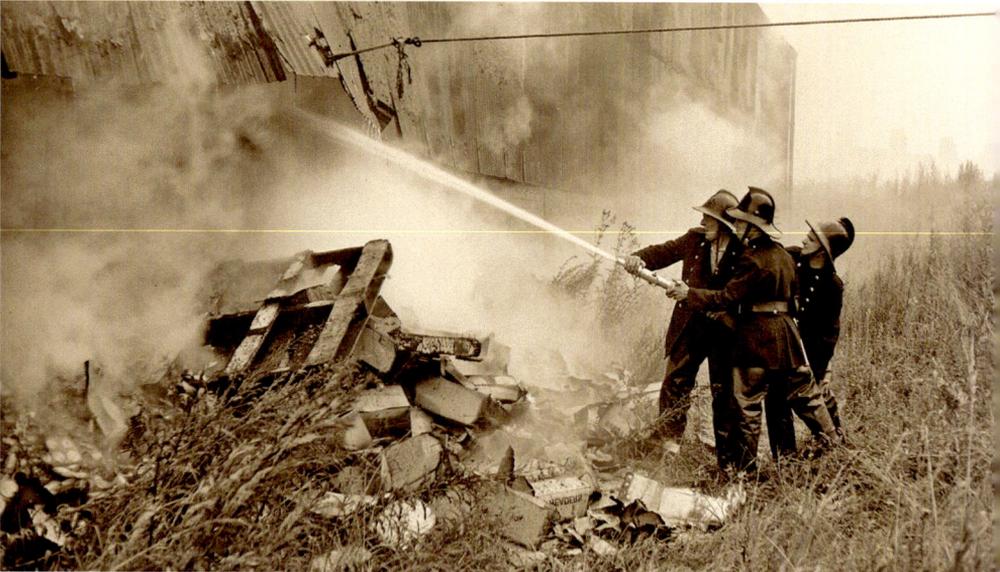

In November 1966 Beatson and Clark increased production of pharmaceutical bottles from four million to five million, employing 450 men at their Stairfoot works. Described as one of the most spectacular blazes ever seen in Barnsley, a Beatson and Clark warehouse containing cardboard cartons and bottles was gutted in July 1966. The firemen had to shield themselves from flying glass and asbestos as bottles exploded. An adjoining warehouse which could easily have caught fire had only just been rebuilt after being gutted by fire earlier in 1966.

When quizzed on crime figures, Chief Constable of Barnsley Ron Gregory, who later made headlines running the Yorkshire Ripper enquiries, complained about staff canteen facilities at Barnsley's Divisional HQ. Gregory said Doncaster and Wakefield had far better facilities. However, the Black Museum, a name shared with a similar museum in Scotland Yard, was provided. The gruesome exhibits included photographs of crime scenes including corpses, a variety of weapons used by the criminals and explosives and detonators used for cracking safes.

In 1967 thirty-five Mini vans replaced motorcycles for patrolling the countryside. The vans had two-way radio to communicate with divisional offices. However, it was fifty-four-year-old Mary Stephenson from Hoylandswaine who helped police catch a nationwide gang of armed robbers. She saw a suspicious man leave a house and went to investigate. Armed with a sawn-off shotgun, the man had broken in, tied up and gagged the owner, his wife and elderly aunt and stole £500. Mary contacted the police, who arrested five men.

In October 1970 there was a 'dirty jobs' strike by employees working in refuse and sewerage. They were seeking a fifty-five-shilling rise to bring the lowest basic wage to £16.10s a week. Councillors complained when Corporation drivers blocked access to depots with their vehicles. Instructions were issued regarding how the public should deal with rubbish. Plastic and paper sacks were placed in strategic locations for rubbish but one of the main hazards was slipping on pavements covered with fallen leaves.

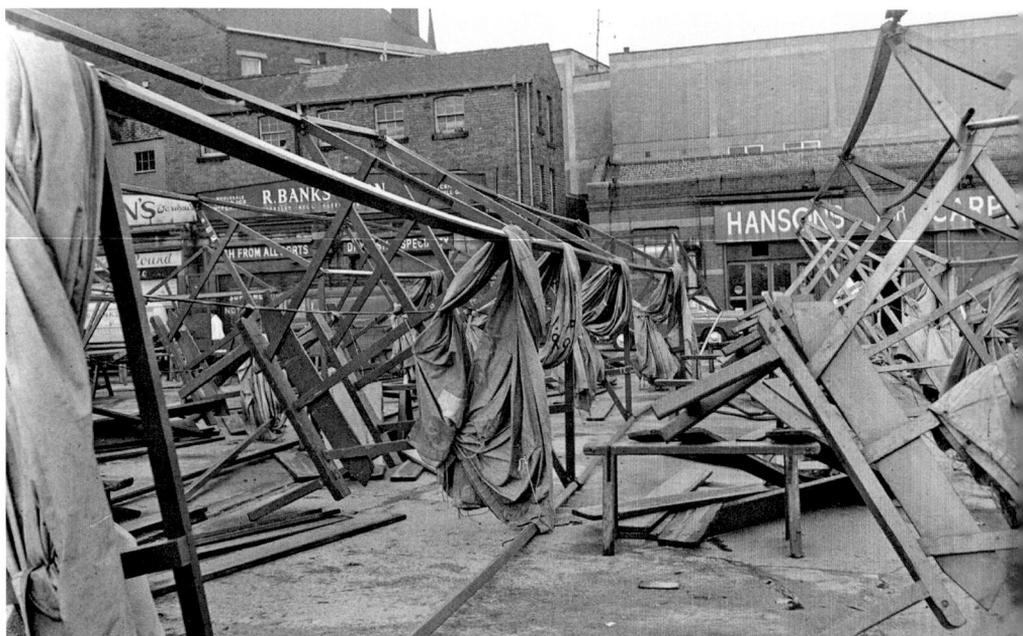

Angry scenes took place in the Open Market when pickets asked market staff repairing market stalls blown over by a gale to join the strike. Market traders had to put the stalls back up themselves. Pickets moved onto the cattle market and abattoir where workers walked out in sympathy. The dispute grew to include gravediggers, crematorium staff and parks employees.

It was claimed Barnsley never closed anything when renovations meant 1,800 operations were being carried out in a tent. Beckett hospital treated 5,000 in patients and dealt with 25,204 patients in the casualty department in one year. Matron Miss Guyll said Becketts was the busiest hospital of its size in the country. Beckett Hospital continued but a new hospital was on the way and recently a fine 1930s building was demolished. A plaque and Baroque-style Edwardian nurses' accommodation from 1906 are all that remain.

Beckett Hospital staff were enjoying the annual dance at the Arcadian Hall in January 1968. At the end of the year a report from the Medical Officer of Health contained a warning about tuberculosis. The threat of spread in the wider community still remained. A mass radiography unit was put in the Town Hall basement but participation fell well below the target. In 1967 thirty-three cases of tuberculosis were reported and seven people had active lesions that could transmit the disease.

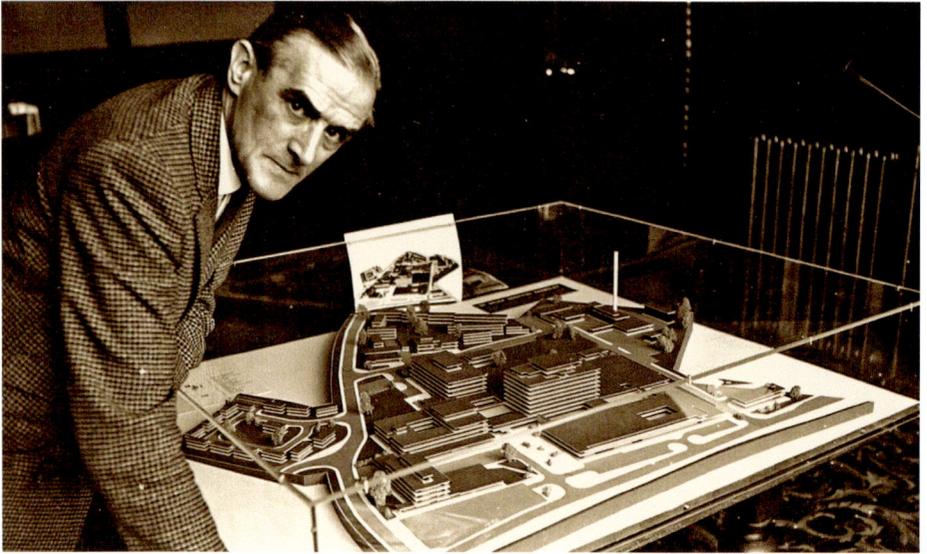

In 1966 the first sod was cut for phase one of the new St Helen's Hospital. In 1967 a model was released showing the view from Gawber Road and in 1969 it was said the new £10 million hospital would change the face of the town. However, St Helen's Hospital Matron Edith Lees attacked 'fireside doctors' giving advice on treatment after watching fictional TV medical programmes including *Emergency Ward 10* and *Dr Kildare*. She wanted warnings at the start of programmes.

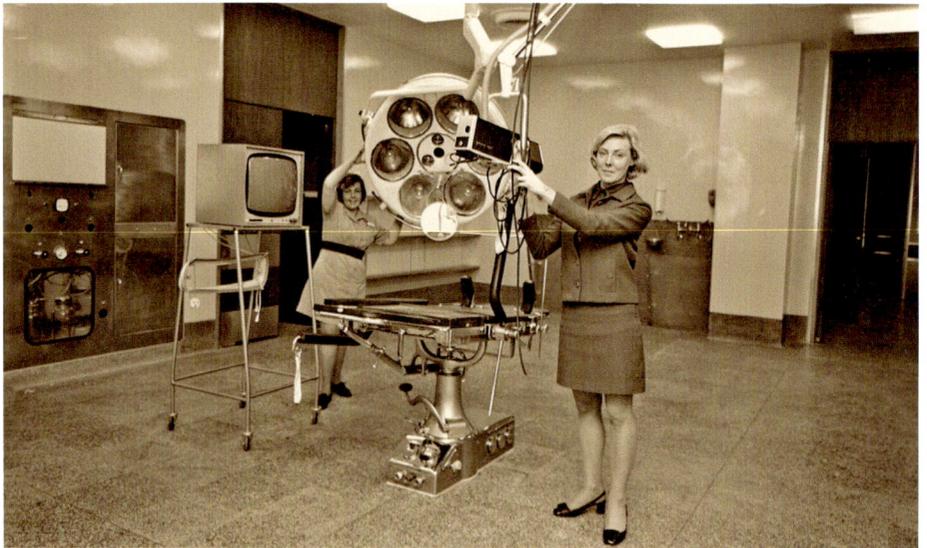

The new maternity unit opened in October 1970. Maternity patients were promised single rooms and Hazel Fletcher, the Matron of Maternity, heralded some of the country's most up-to-date equipment including a closed-circuit TV link between operating theatres and remote training facilities. The aim was to get rid of the grim image of old hospitals. Earlier that year a flu outbreak caused GP surgeries to become overstretched. Eighty-three Barnsley Hospital staff were off sick and admissions were restricted to emergencies.

Along with a new hospital Barnsley would have the first fully equipped coronary care ambulance in the north of England and half of the requisite £5,000 was raised through the 'save a life a day' appeal promoted by the *Chronicle*. Two young Athersley girls, Jane Sheard and Lynne Cooper, held a jumble sale and sold their old toys to raise fifteen shillings. The ambulance came into service in November 1969 and coronary care pioneer Dr J. F. Partridge of Belfast was very impressed with Barnsley's facilities.

The 144-year-old Salvation Army Corps Citadel has been in a semi-derelict state for many years. However, the future of the Citadel had already been in serious jeopardy in 1966 when a planned road scheme would have wiped it out. Commanding Officer Captain A. Thompson Wood was forced to consider alternative premises as near and as soon as possible. The corps, one of the oldest in the country, commenced raising the requisite money to add to the expected compensation and legacies.

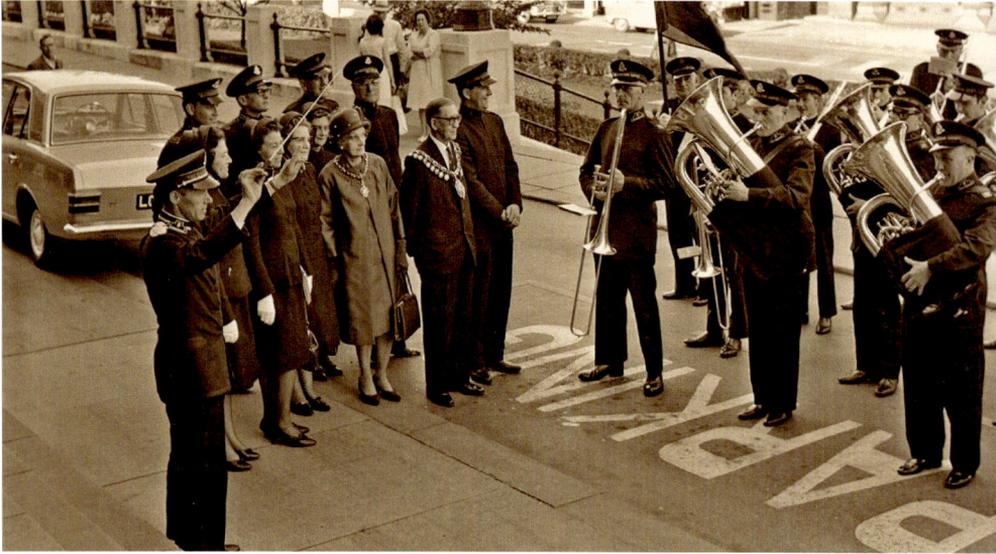

The Salvation Army Sunderland and Wearmouth Band were playing in 1967 when Mr and Mrs Wood were Commanding Officers of the Citadel. A farewell service was held at the Citadel in May 1967, when they left to go to Chalk Farm, North London, as part of the annual Salvation Army change around. In just one year they set up Junior and Senior Torchbearers groups and launched a new instrument appeal providing instruments worth £1,700. Both were accomplished musicians and had compositions published by the army.

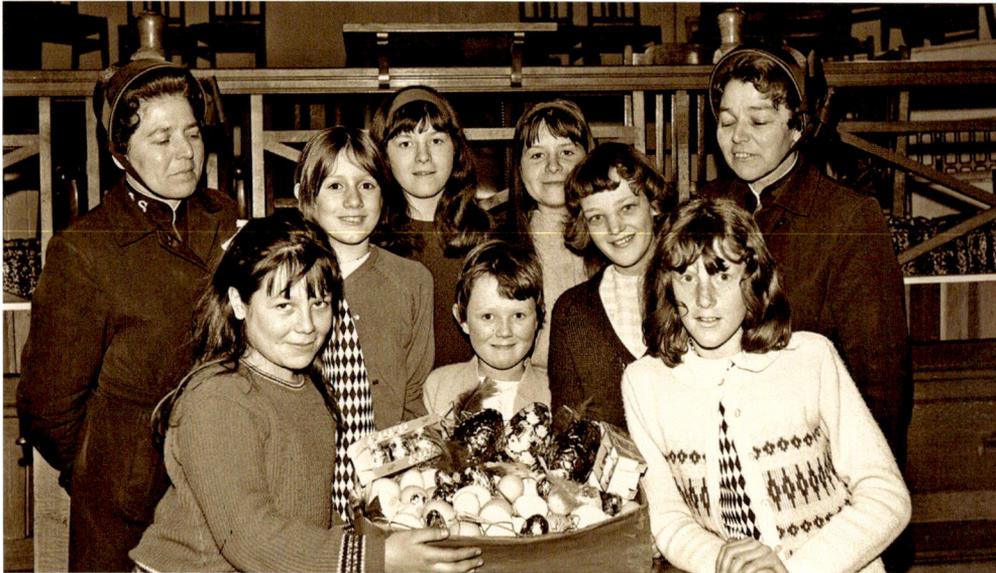

In March 1967 young members were giving chocolate eggs to Kendray Hospital. The new Commanding Officers were Major Remmers and Auxiliary Captain Florence Pacey. The Citadel hosted 'The Drummers Fraternal' who gave a series of concerts in a tour of the whole country. The group was made up of eleven drummers from various Salvation Army bands based in Yorkshire. This was the group's first appearance in Barnsley. The Salvation Army was clearly active in the town as it also had a mission on Albion Road.

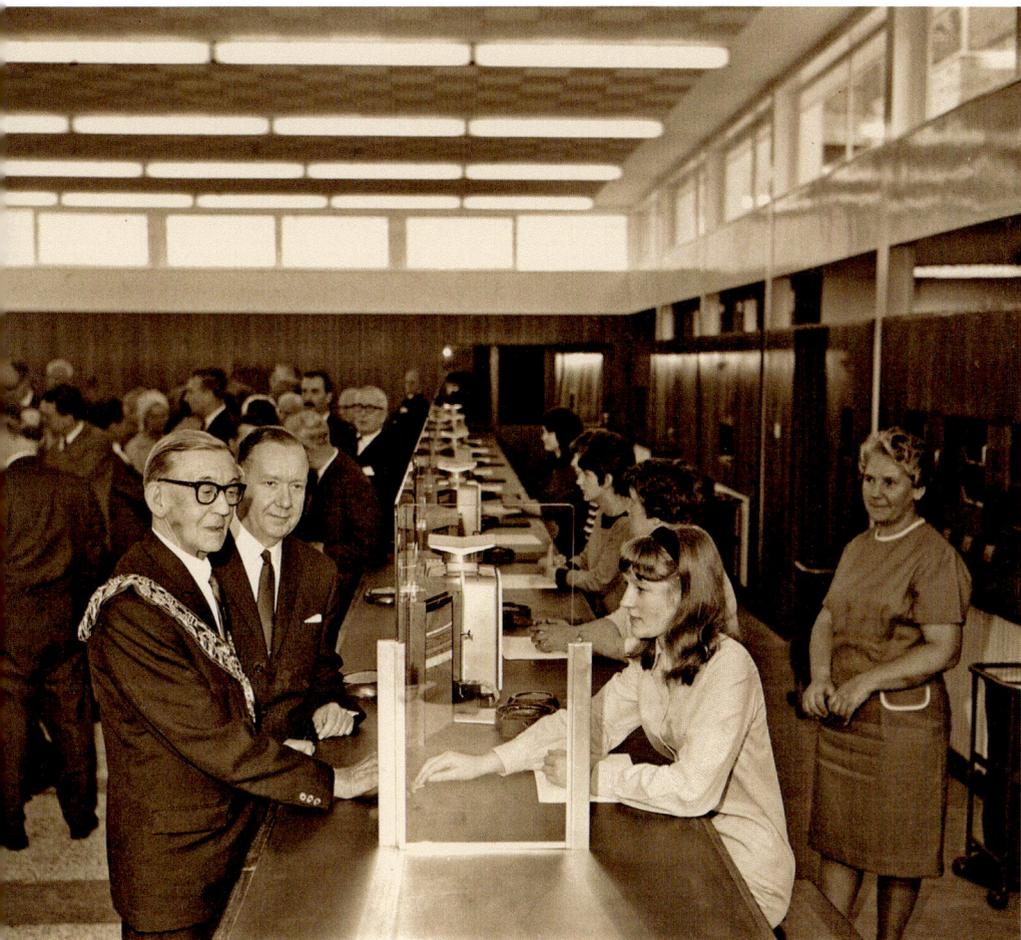

Chief Postmaster Dudley Coupe was not happy because his appeal for local residents to bundle their Christmas mail had been ignored. However, a spokesperson for the fire brigade said Barnsley's brand-new post office could have been inoperative over Christmas 1966 after a fire in a boiler used for melting bitumen. Numerous propane gas cylinders stored in the rear yard could easily have exploded. Only two years previously fewer propane gas cylinders exploded near the Arcade, blowing out shop windows on Market Hill.

Town Centre

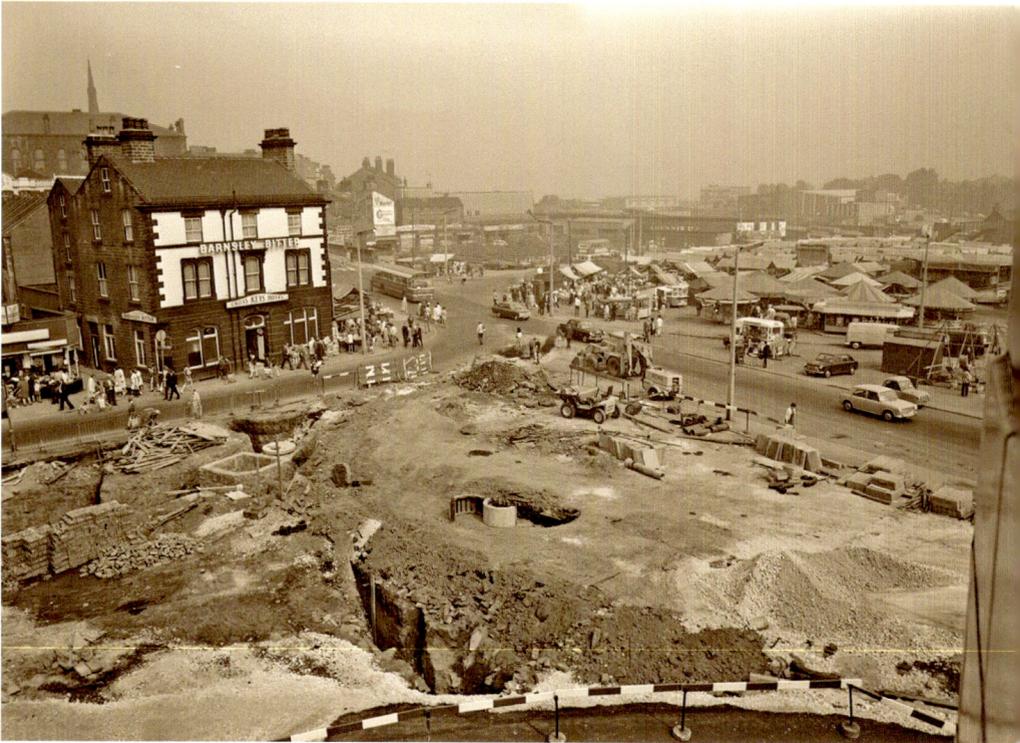

The first town centre redevelopment was published in 1964. It was claimed that the grand plan would get rid of the 'Black Barnsley' tag. The Barnsley British Cooperative Society president Colin Dransfield was critical of building on the open market instead of 'bombed sites'. Headlines appeared saying Barnsley would seem like a ghost town and in March 1970 shopkeepers complained demolition work was causing a plague of mice immune to normal poisons.

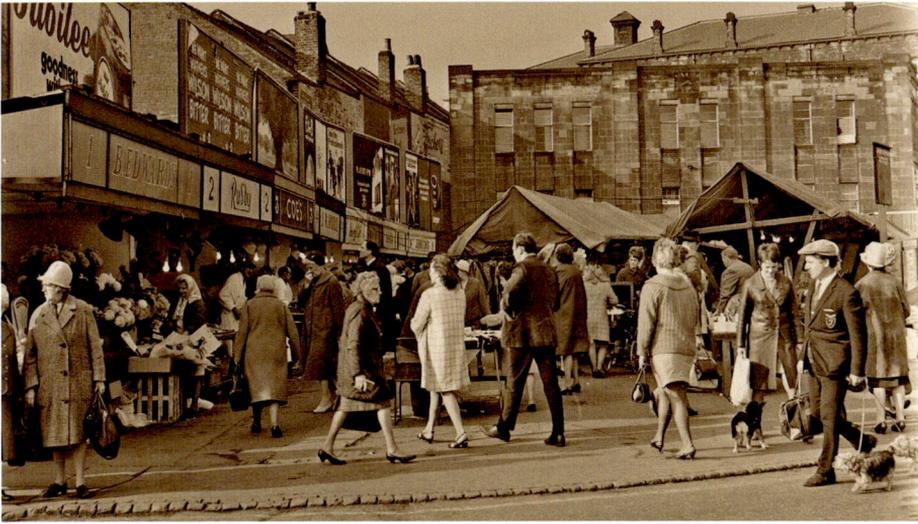

An editorial on 3 October 1970 reported growing public concern about the loss of the magnet for visitors to the town, saying it was tragic that the council had failed to communicate the true nature of the drastic reduction of the open market. A petition demanding retention of the open market was deemed too late as plans for a larger covered market had been available for years. The market's superintendent, A. P. Birkinshaw, said an 'each way' bet had been placed on winter gains versus summer losses.

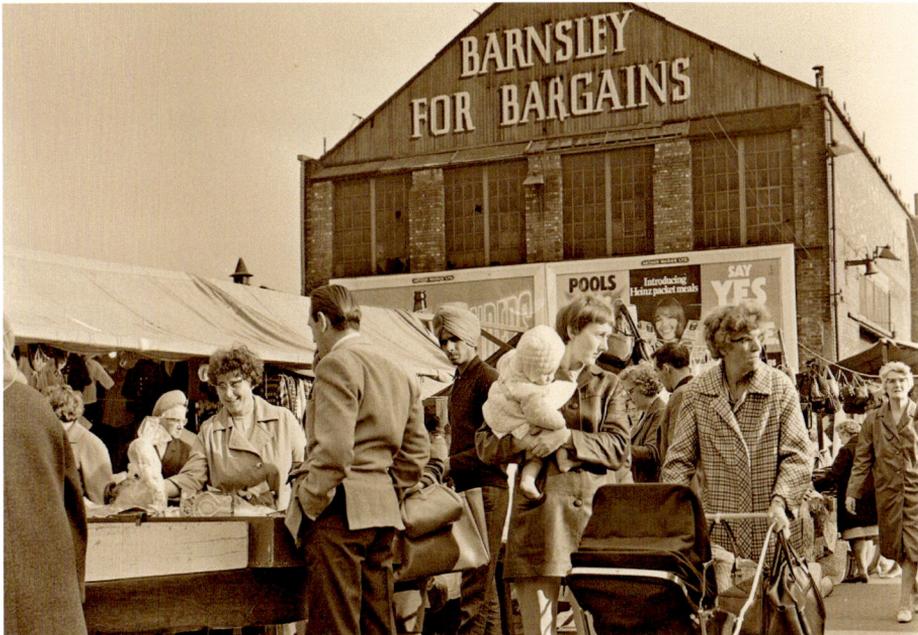

The original market's charter was from 1249 and for the first time it was proposed to consolidate the markets on one site with fewer open-air stalls. The Council were advised they needed additional powers via an Act of Parliament to change the 700-year-old markets. At the same time Hoyland, Dodworth, and Darton wanted to establish their own markets because their residents didn't benefit from 'Barnsley for Bargains' because of travel costs.

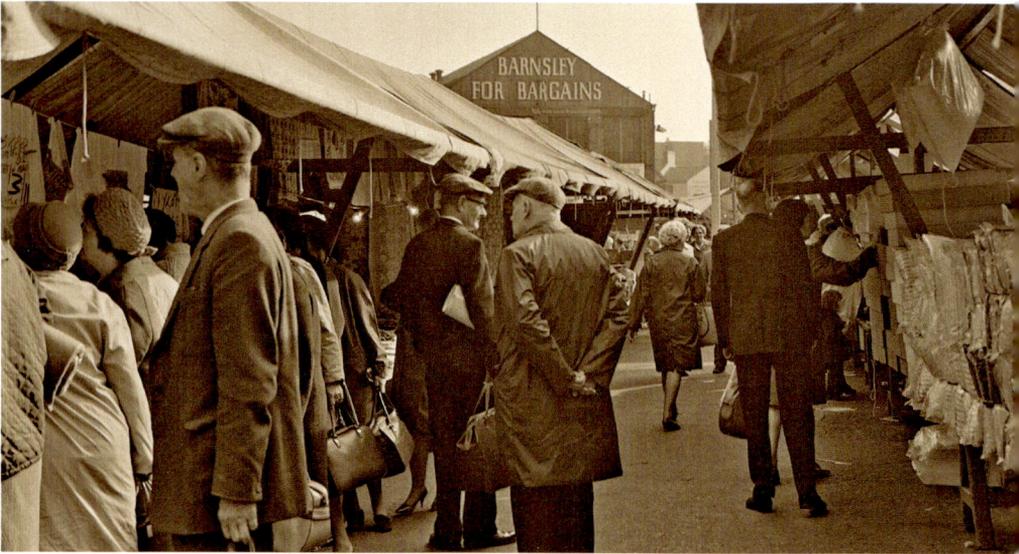

Amongst the many personalities on the Barnsley open market was china and crockery trader and highly successful businessman Joe Edwards. In the 1970s he was the original TV 'dragon'. The BBC ran a documentary on his life and he regularly appeared on the small screen, including the *Frost* and *Dave Allen* shows. His son Lance had a role in *Coronation Street*. Meanwhile temporary market stalls erected during the town centre redevelopment caused lost revenue because regular customers were finding it hard to locate their favourite stalls.

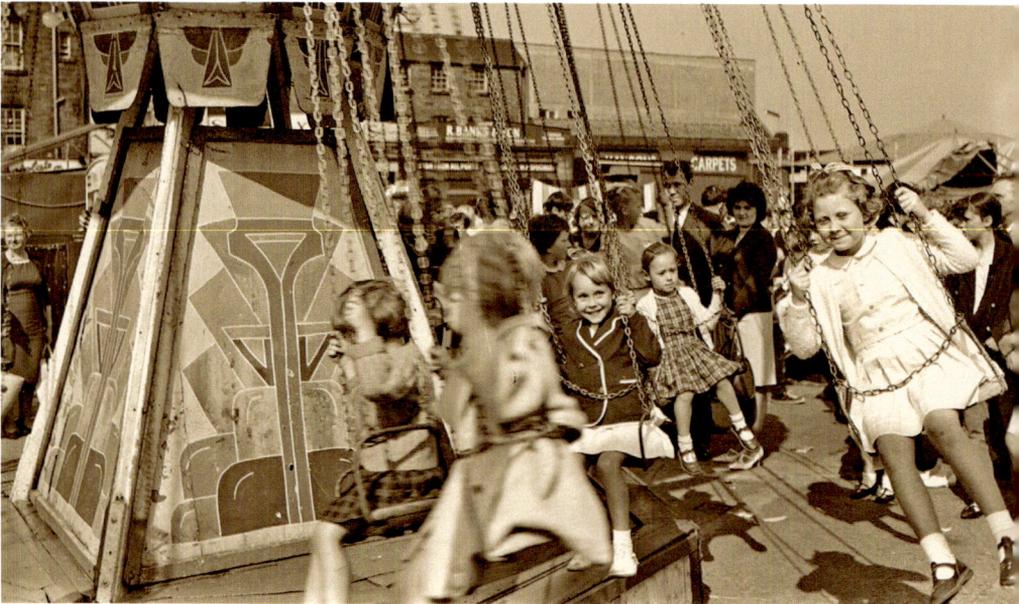

In May 1969 G. Tuby, spokesman for the fair owners' guild, said the future of the fair would be put at risk by the town centre redevelopment. The Corporation's alternative on the Queens Ground was a terrible location. In March 1970 it was confirmed the 1969 Barnsley Feast had been the last with a fair. Mr Tuby said it is not a nice feeling to be thrown out of the town after so long; there was a time when the Corporation were begging for the showmen to come.

By December 1966 initial proposals for a hotel and cinema were dropped and replaced by a five-storey block of flats in order to 'keep the place alive day and night'. However, the Barnsley Coperative urged the Town Council to reconsider putting eighty-two new shop units in the scheme. Colin Dransfield asked, with so many shops already empty how such a large increase would help? It was feared they would just bring in more national multiple retailers.

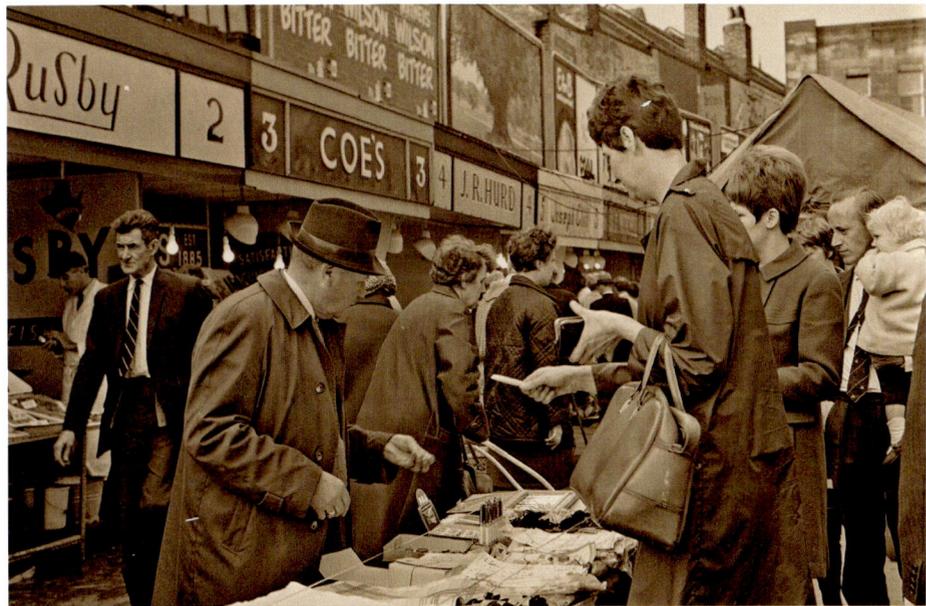

Speaking at Keresforth Hall, Albert Hirst said local traders would be priced out of new 'empty shell' shops that needed expensive fitting-out paid for by the traders. He warned that local traders would not be able to compete against the big boys. A Liverpool delegate said Councillors are little men yet they approve plans to tear down the livelihood of other little men. Outsiders' erect monstrosities and charge rents beyond the reach of the small man.

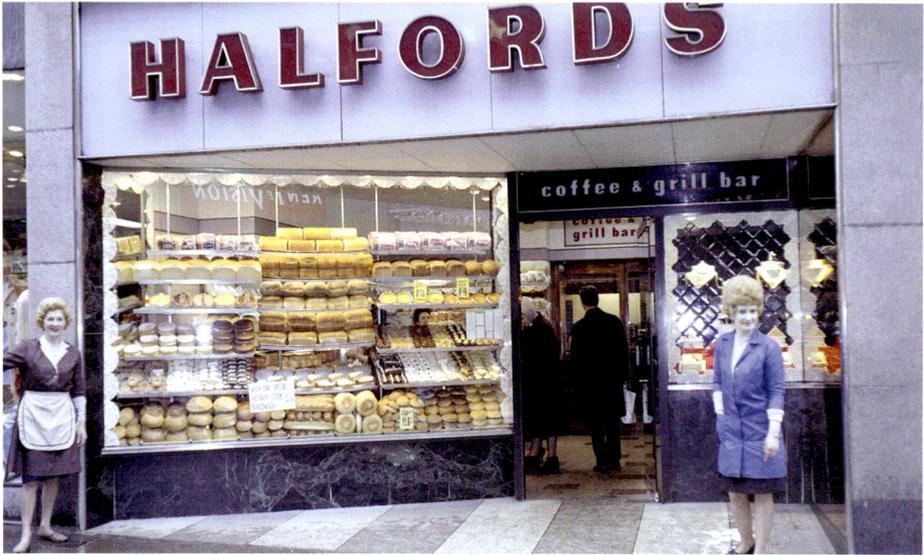

Many local shop names disappeared under pressure from new multiple shops. Halfords, pictured in October 1966, was a local shop name that survived, albeit not for these owners. Horsfield's department store on Sheffield Road, founded in 1863, was originally a pawnbroker. It became the original cut-price shop. The store still had a chute system to transport payments to the clerks' back office. It was demolished in August 1970 after the shop manager, Denton Wilson, had worked there for over fifty years.

Butterfield and Massey's advertised a consignment of exceptionally cheap merchandise that was delayed in transit. Amongst the bargains were crimplene suits for 59s 11d and Ocelot-print nylon macs for 25s. The 1970 Butterfield's Father Christmas came to town as part of a procession led by a brass band. Only a week later Santa reprised the brass band procession for the Joseph Peck Department Store Christmas Grotto. Blamshires reported sales of expensive wines had increased at Christmas due to more holidays abroad.

In November 1967 Miss Denmark Sonja Jensen cut the ribbon at Tesco's Spedding's Fold store where home-n-wear customers could have their fortunes read by Madame Ruby free of charge. In 1976 Tesco sold the store to Boots the Chemist as it was no longer big enough for their needs. In October 1969 Miss Slimcea Beverley Dunn opened the town's first Asda store on Laithes Lane, New Lodge. In April 1969 Lipton's Stores on Pitt Street obtained a liquor licence reliquished by Timothy Whites Chemists.

This car park once contained one of the Barnsley Cooperative's stores. On 11 July 1970 hundreds of teenagers and children swarmed into these stores to see Jimmy Savile during the Cooperative's 'Big Week'. He arrived in his white Rolls-Royce wearing a white BBCS hat. He posed for photographs with the girls of the hairdressing salon and had a race in a sailing dingy. He bounced on a bed with some 'dishy dollies' and met ICI paint Supercover girl Miss Marianne Smith and the ICI Old English sheepdog Seamas.

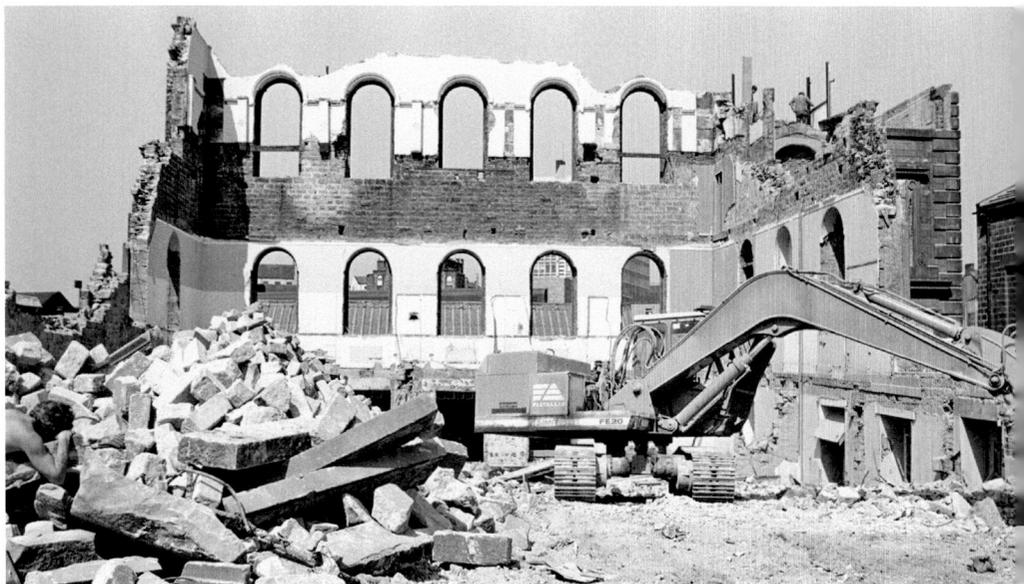

In 1968 it was reported that dry rot in the basement of Pitt Street Methodist Church had been defeated, but this fine building was lost to demolition in 1984. It was part of Barnsley's cultural heritage, being one of the venues for the annual Barnsley Music Festival. The festival had sections for speech, dance and music. In 1966 the judges included Barnsley's twenty-four-year-old Pearl Fawcett. She was the 1961 world champion accordionist and had enjoyed a summer season at Filey and a Far East tour.

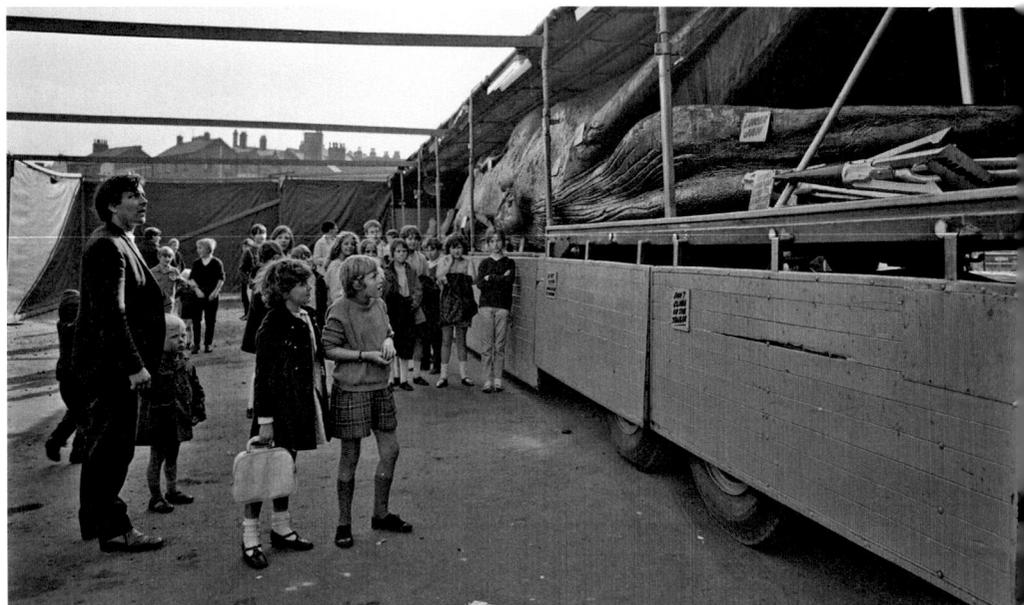

Jonah the giant whale was caught and preserved in 1965. To highlight extinction fears, he travelled the world on the longest single articulated lorry in Europe. At the end of his long trek, he came to Barnsley in October 1970. The pre-publicity was all about Jonah's colossal scale but the *Chronicle* headline read 'Giant whale a flop'. Scaffolding retained its shape, the jaws were propped open, the skin was coated with tar and he smelled terrible.

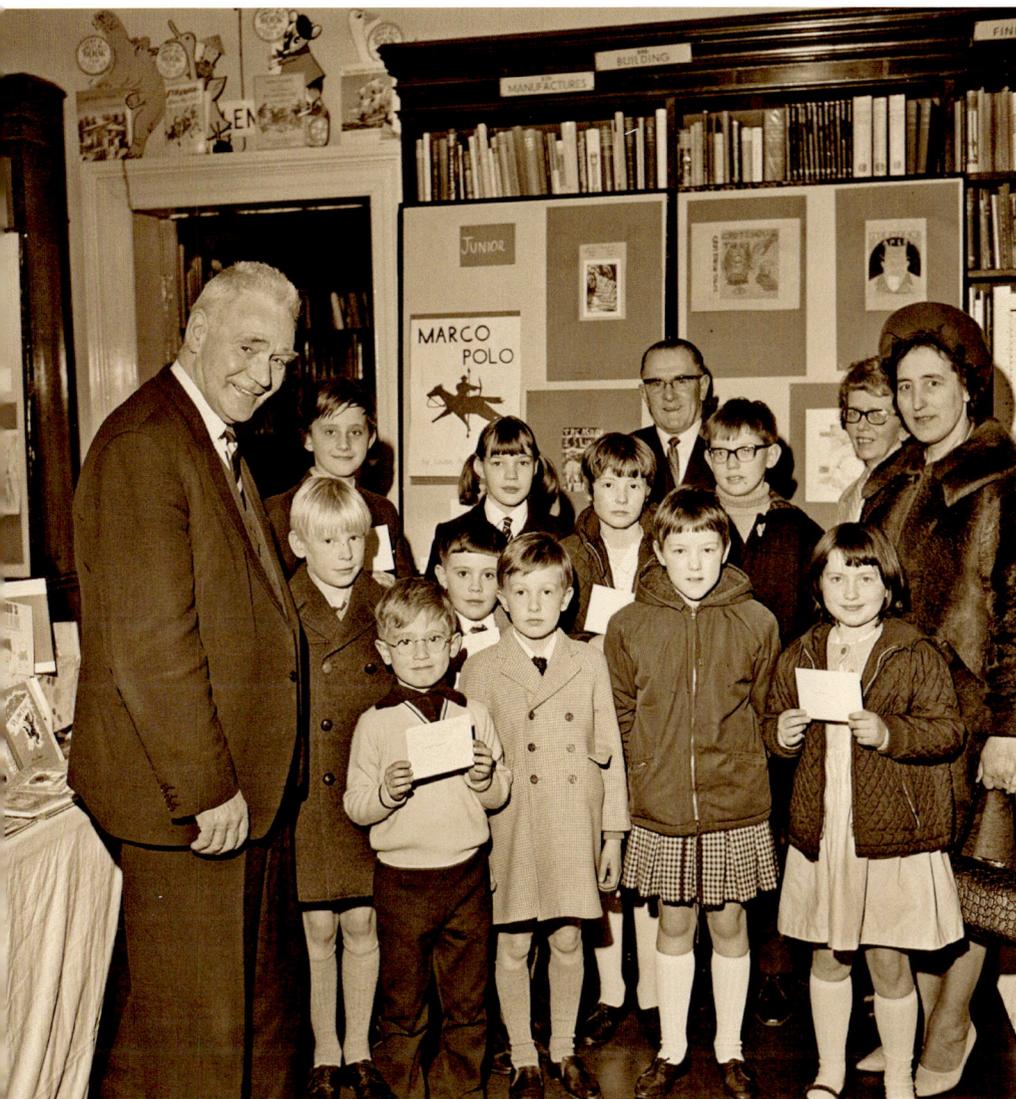

In March 1967 there was a National Library week as a new library was due to open on Shambles Street. Barnsley has a long tradition of local history writers. However, Alastair Parker, born in Barnsley in 1927, was a celebrated national historian and the *Guardian* obituary said he was the leading authority on the origins of the Second World War. He lectured at Manchester University and Queen's College, Oxford and wrote four highly influential books under the name R. A. C. Parker.

Education and Church Matters

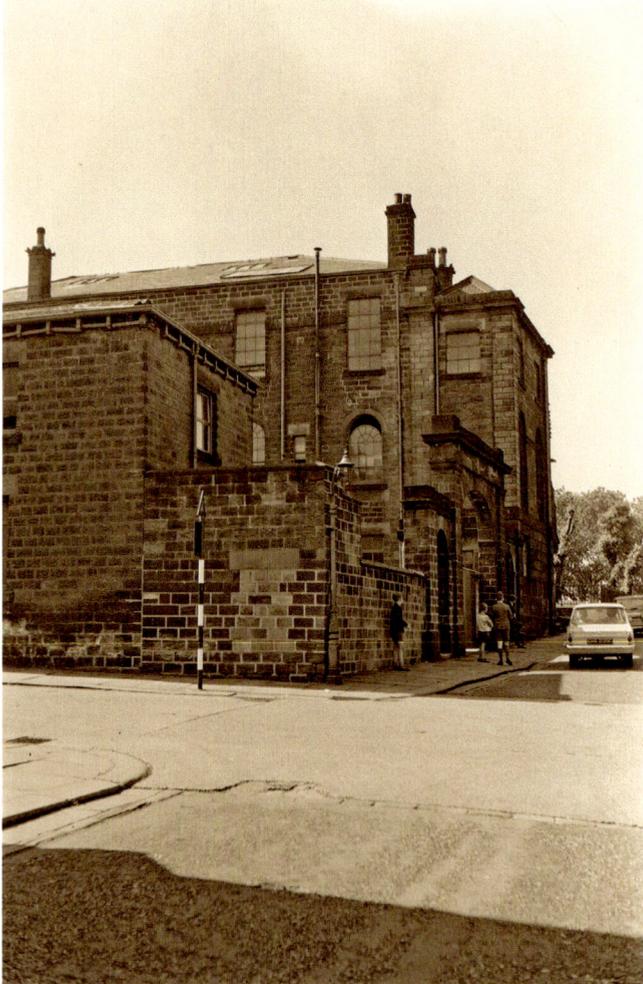

Mark Street Central School was for pupils not destined for Grammar School. When it was demolished in March 1969 the *Chronicle* described it as a grim Dickensian school that was originally built as a textile factory. The paper said it had poor facilities including a poky playground bounded by intimidating high walls. However, the article failed to mention the hugely impressive central classical triumphal arch between two smaller arched entrances. The adjacent Gothic church was also demolished.

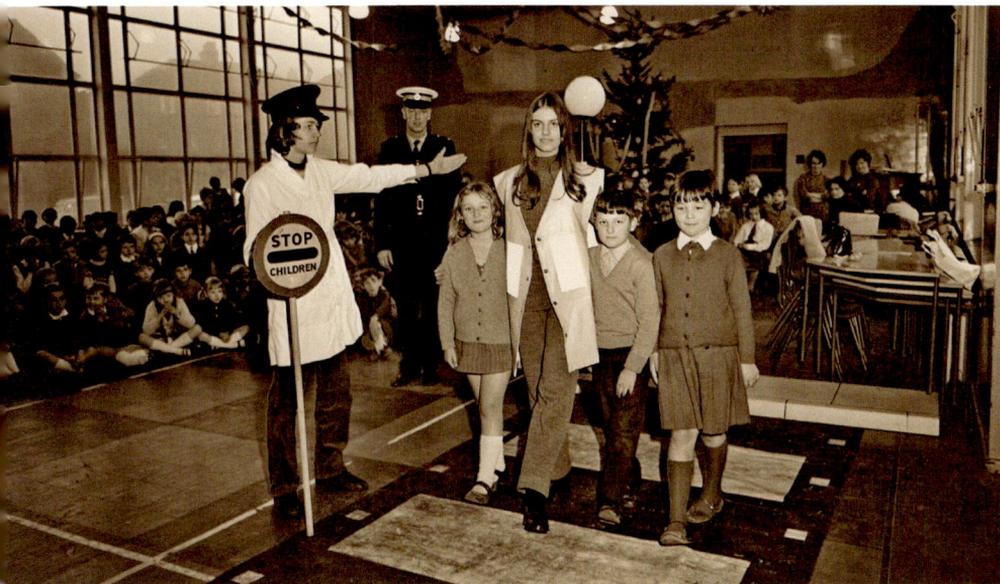

This road safety class was at Wilthorpe Primary School in December 1970. In July 1968 a widely acclaimed road safety exhibition was produced by the pupils at Agnes Road primary school. Head Teacher Hilda Mosely was keen that road safety become part of the national curriculum. Education was addressing social issues associated with the rise of youth culture. However, in May 1970 Barnsley's Education Committee decided BBC-produced sex education film strips would not be shown in primary schools.

Agnes Road school's summer fair took place in June 1967. The 1870 Education Act led to a boom in high-quality school building. The single-storey stone school had a steep blue-slate roof with two prominent gables with a finial. Within these was an arch formed by a raised ashlar moulding with ashlar stone details. The windows had heavy stone lintels and mullions with four lights below a pair of lights fitted centrally to fit within the arch.

The Broadway Grammar School recorder group were performing in November 1965. The school overlooked Keresforth Hill and enjoyed far-reaching views of the countryside beyond. The site contained two separate buildings, one being the Charter Comprehensive, and these combined to become the Kingstone Secondary School. The school's Kingstone Concert band toured internationally before the school closed in 2012 and the pupils transferred to the new Horizon Community College that amalgamated the Holgate and Kingstone schools on the former SR Gent factory site.

This was the Barnsley (Holgate) Grammar School old boys' dinner from January 1968 and it was the famous alumni that justified failed attempts to save the building. Albert Hirst worked in his father's butcher's shop when still a pupil. Other notable pupils included Dave Burland, Brian Glover, Michael Parkinson, Stan Richards, and Jimmy and Brian Greenhoff. Strictness was displayed in October 1970 when a bomb hoax called into the Barnsley Police HQ only caused a five-minute delay to the start of assembly.

This is the Edward Sheerien Speech Day in November 1965. Named after a former Mayor of Barnsley, it was opened in 1957, the town's first new post-war secondary school. The school is often associated with the film *Kes* because it was located adjacent to St Helen's School where it was filmed. It closed on 31 August 2009, and the two schools amalgamated to become St Michael's Catholic and Church of England School. The school was subsequently renamed Holy Trinity.

This Speech Day in November 1966 was at Kirk Balk, another school associated with *Kes*. Barry Hines lived in Hoyland, taught here and much of the film took place in the surrounding area. *Kes* concerned failing selective education and in 1966 Barnsley Education Committee had not set a comprehensive education starting date despite children following a curriculum based on an understanding that there would be no eleven plus exam in 1967. It was still being reported who had passed the eleven plus exam in 1969.

In May 1967 apprentices are pictured at the Technical College. All the top executives and shop floor personnel at Qualter and Smith Brothers were trained at the college. The design team produced an advanced drilling machine using a tape system to control operations. The machine went on show at the London Tools Exhibition in July 1968. The system was not entirely unique but the company believed they had improved its quality and reliability and it was the latest addition to their 'made in Barnsley' range.

Karate was amongst many activities on offer at the YMCA. In May 1969 the Young Men's Christian Association celebrated 125 years in Barnsley with an open week of events including a volleyball match with some Barnsley FC footballers and weightlifting with former Olympic athlete Arthur Rowe. Besides the original premises on Eldon Street in 1966 the Barnsley YMCA Operatic Society presented a Dance Review by Mavis Burrows School of Dancing at the new YMCA Hall on Pitt Street.

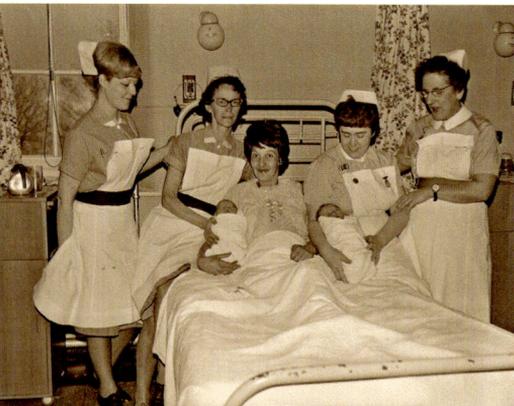

In December 1966 the hospital broadcasting network Radio Barnsley provided twelve hours of entertainment on Christmas Day from their YMCA studio on Pitt Street. These Christmas day babies may have featured. This included Candid Camera stuntman Bill Kellie from Barnsley, a version of 'Juke Box Jury' called 'Radio Barnsley Predicts' and many other features. The radio programmes were produced mostly by teenage members of the YMCA Tape Recording Club. The YMCA had been making weekly broadcasts since 1961 and did the first twelve-hour broadcast in 1964.

Transport and the Weather

In September 1968 two buses collided after vandals released the handbrake on one, setting it trundling downhill before hitting the second. After another accident on Christmas Eve 1966 a woman lost five toes when her right foot got stuck under the wheel of a reversing double-decker at Barnsley bus station. Joseph Jessop, who worked for Yorkshire Traction for thirty years, drove one of the town's first taxis, when vehicles had paraffin headlights. The taxi rank was outside the White Hart Hotel in Peel Square.

These pensioners were embarking on a mystery tour. In August 1968 a special fleet of coaches ferried over 4,000 people leaving Barnsley for Feast Week. Blackpool and Skegness were the two most popular destinations. To cope with demand many coaches used Magnet Bowl car park for pick-up. In October 1970 Darton Council banned a 'Bingo Bus' following complaints it was blocking access to the houses and a chapel. Another special bus was a free hourly 'Simco Special' serving the Town End supermarket.

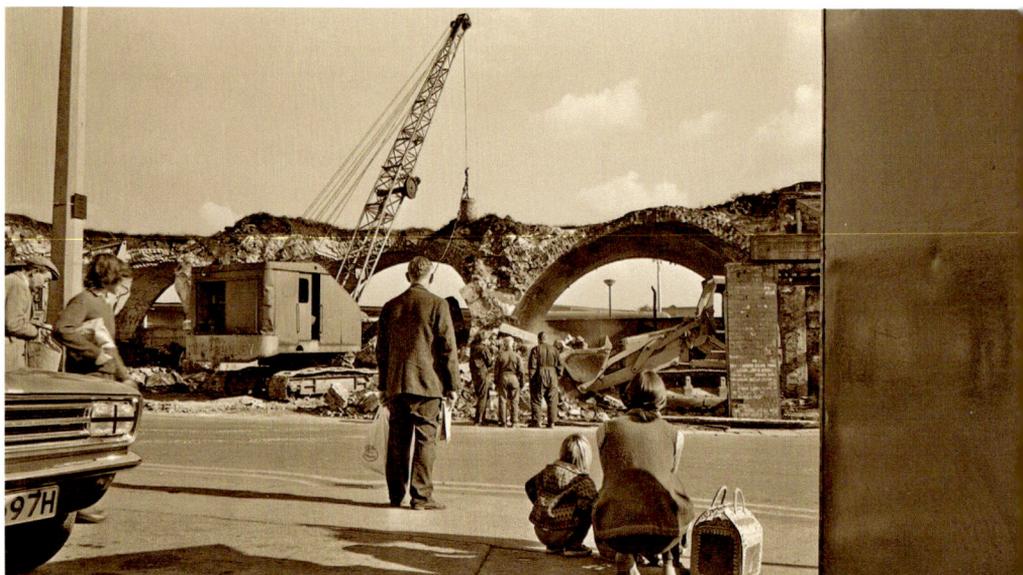

In October 1970 the demolition of the Court House railway station was underway, heralding other significant changes along the discontinued route. The Cudworth Flyer connected Barnsley to main-line services via the Oaks Viaduct (another viaduct passed through the town centre). In June 1968 it was announced that the Oaks Viaduct was to be demolished after a water pipe it carried across the valley was disconnected. The massive structure, built in 1863, took the Cudworth Flyer 100 feet above the ground and spanned 362 yards.

Post-Cudworth Flyer transportation of coal continued for some time at Cudworth station. In 1893 the railway station was isolated. By 1906 some high-density housing, including Charity Terrace, had appeared at Klondyke. In 1931 housing called Newtown was still some distance away to the east of the station. By 1961 there were houses abutting the station with the rapid growth of Cudworth. Today the water tower is the only substantial reminder of the station which lingers by defining a highly attractive countryside walk.

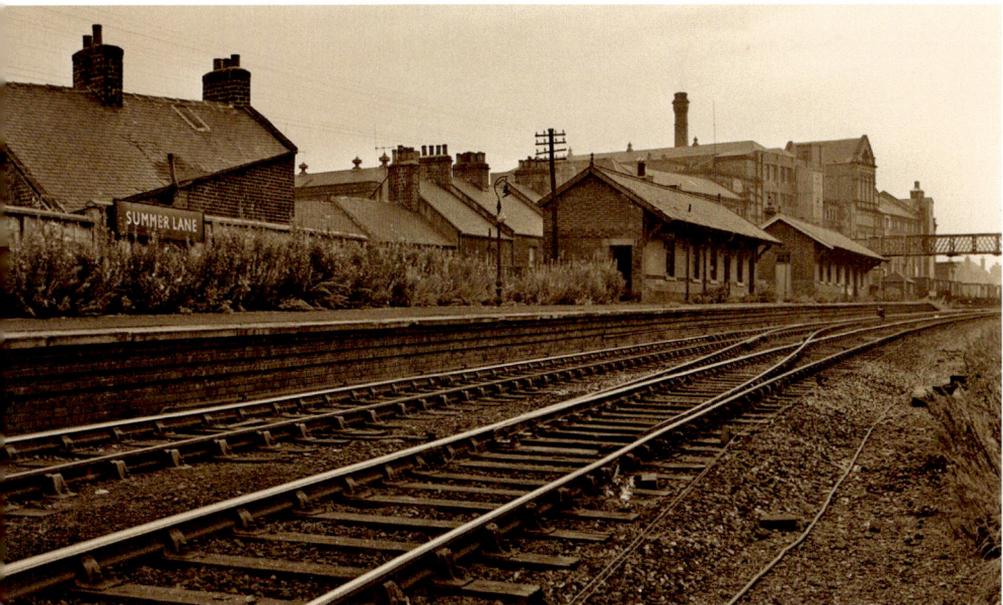

The railway line on which Summer Lane railway station once stood still carries trains and the 'low bridge' is a dominant feature in the street scene. The impressive saw mills can be seen in the background. In November 1966 the proposed closure of the east coast railway line meant holidaymakers would have to travel by road. Barnsley Town Council wrote to the Minister of Transport Barbara Castle to object, saying existing traffic jams near Malton will be exacerbated.

The Barnsley Canal, built in the 1790s, closed in 1953 following many problems including mining subsidence. A small section remains and the towpath accessed via Twibell Street leads to the superb Dearne Valley Country Park. Across a busy gyratory is Canal Street, which was once on the canal side. Opposite the Keel Inn a footpath provides access to the Fleets inland waterway, an anglers' favourite. Besides coal connections glass makers such as Redfearn's, Beatson and Clark, Wood Brothers and Rylands took advantage of the canal.

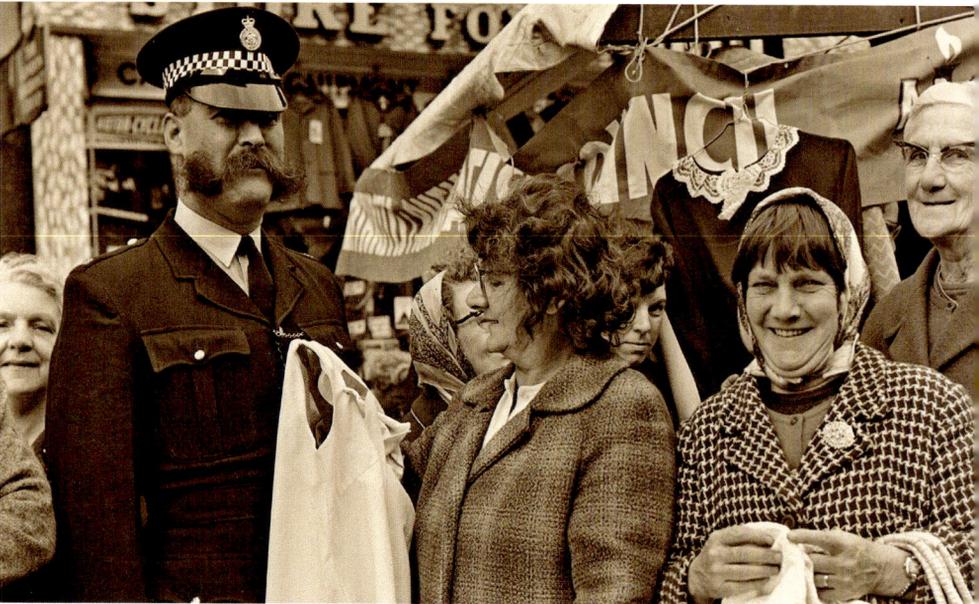

Barnsley's most charismatic bobby was Bill Harber MBE. The white-clad traffic cop with a handlebar moustache was an eye-catching figure amongst the chaos. In September 1968 the traffic deadlock was to be relieved via changes in the May Day Green/Gas Nook Street area and a controversial plan for 'no waiting' on the majority of town centre streets. In December 1970 Bill had the time to judge a fancy-dress competition at the Gawber WMC ladies' section annual dinner and social evening.

In November 1968 an irate steelworker from
Cudworth assaulted a traffic warden after
parking on a no waiting area. He threatened
to run over the traffic warden but instead
gave him a 'little' karate chop on the back of
his neck. He drove off ignoring a policeman's
warning to stop for pedestrians at a zebra
crossing. He later told the court he was a
karate student, so if he really had hit the
warden, he would have killed him. He added
he was wearing driving gloves that cushioned
the blow.

When a thunderbolt struck a house in New
Lodge in May 1968 the owner thought a
bomb was exploding, but 1970 proved equally
unpredictable. In March 4 inches of snow
brought chaos and it took over an hour to drive
from Town End to Sheffield Road. By October
a drought meant the Summer Ford Bridge in
the Ingbirchworth reservoir was exposed for
only the fifth time in eighty-six years. A month
later 60-mph gales caused havoc, including a
flagpole crashing through the window of a bar
at the Queens Hotel and a council bricklayer
being blown off a roof.

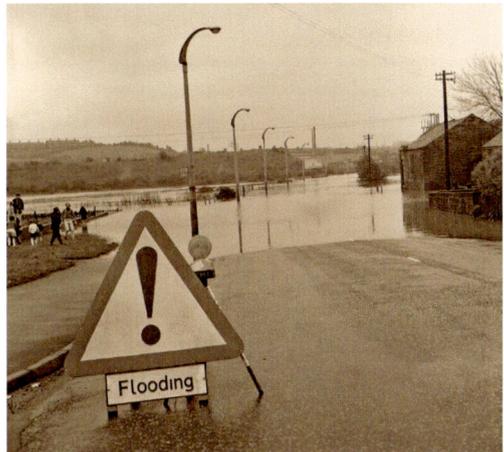

In April 1970 water was knee deep in Darton
after a day-long cloudburst. The banks of the
River Dearne burst, flooding the brand-new
sewerage works and left a recently erected
house stranded. However, the fire service
said that the flooding was not as bad as in
the previous year when a cloudburst caused
mass flooding in Barnsley town centre. At
Smithies the Fleets Dam was breached and
in Grimethorpe St Patrick's Roman Catholic
Church was flooded, although Sunday's evening
mass continued as normal.

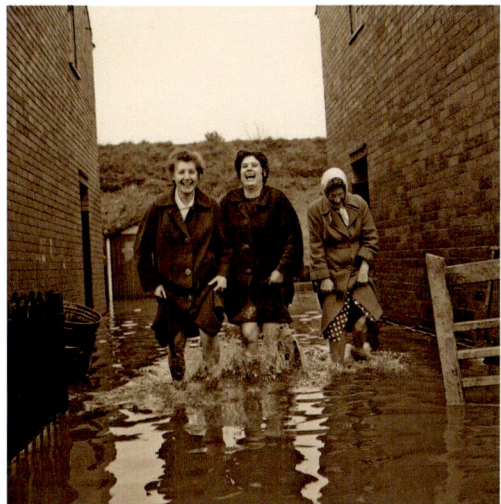

Acknowledgements

This book would not have been possible without access to the Sabine Collection and the help and assistance from Paul Stebbing and everyone at Barnsley Archive including Davis Blunden, Mark Levitt, Katy Best, Helena Quinn and James Stevenson. The majority of the material is taken from Barnsley's *Chronicle* articles. The Sabine Collection was suggested by Paul Darlow at the NUM headquarters in Barnsley. I had suggestions from my brother Jeff and Nigel from Skelmanthorpe Male Voice Choir. Proofreading was carried out by my partner, Sandra Haigh.

Special thanks go to Granville Daniel Clarke for information and use of his images.

'LAST OF THE WINTER LIGHT'

WORSBOROUGH HALL, BARNSLEY – S.YORKSHIRE.

An original Watercolour by Granville D. Clarke F.R.S.A.

Reproduced by kind permission of the Artist.

The Foggy Dew-O Photo

Photographed in Granada TV studio, live recording for 'Scene at 6.30'

About the Author

Keiron has previously written *Barnsley in 50 Buildings* but was brought up in Cliftonville on the seaside near Margate. A member of the Barnsley Civic Choir, Mirfield Choral Society and Skelmanthorpe Male Voice Choir, he has sung with a number of brass bands including the Black Dyke Band and with some very talented soloists and accompanists. Singing allows visits to some grand town halls and magnificent cathedrals and churches. He and his partner Sandra like going to theatres and concert venues and often combine this with visiting their son Leo and daughter-in-law Jayshrie in London.